MIXED SIGNALS

MIXED SIGNALS

ARTISTS CONSIDER
MASCULINITY IN SPORTS

Christopher Bedford

with an essay by Julia Bryan-Wilson and an excerpt from an essay by Judith Butler

MATTHEW BARNEY

MARK BRADFORD

MARCELINO GONÇALVES

LYLE ASHTON HARRIS

BRIAN JUNGEN

KURT KAUPER

SHAUN EL C. LEONARDO

KORI NEWKIRK

CATHERINE OPIE

PAUL PFEIFFER

MARCO RIOS

COLLIER SCHORR

JOE SOLA

SAM TAYLOR-WOOD

HANK WILLIS THOMAS

INDEPENDENT CURATORS INTERNATIONAL, NEW YORK

Published to accompany the traveling exhibition *Mixed Signals: Artists Consider Masculinity in Sports*, organized and circulated by iCI (Independent Curators International), New York

Exhibition curated by Christopher Bedford

Mixed Signals is an expanded version of *Contemporary Projects 11: Hard Targets — Masculinity and Sports*, an exhibition curated by Bedford and organized by the Los Angeles County Museum of Art.

EXHIBITION FUNDERS
The exhibition, tour, and catalogue are made possible, in part, by The Horace W. Goldsmith Foundation, the iCI Advocates, the iCI Partners, Agnes Gund, Gerrit and Sydie Lansing, and Barbara and John Robinson.

EXHIBITION ITINERARY*
Cranbrook Art Museum at Cranbrook Academy of Art
Bloomfield Hills, Michigan
February 1–March 29, 2009

Center for Art, Design and Visual Culture
University of Maryland, Baltimore County
Baltimore, Maryland
October 8–December 12, 2009

* at time of publication

LENDERS
Adamson Gallery / Editions, Washington, DC
Bespoke Gallery, New York
Mark Bradford
Deitch Projects, New York
Gladstone Gallery, New York
Marcelino Gonçalves
Jay Jopling / White Cube, London
Brian Jungen
Casey Kaplan Gallery, New York
Shaun El C. Leonardo
Marcia Goldenfeld Maiten and Barry Maiten, Los Angeles
Rhys Mendez Gallery, Los Angeles
Eileen Harris Norton, Santa Monica
Catherine Opie
Paul Pfeiffer
Lois Plehn, New York
The Project, New York
Regen Projects, Los Angeles
Rennie Collection, Vancouver
Collier Schorr
Jack Shainman Gallery, New York
Sikkema Jenkins & Co., New York
Hank Willis Thomas
303 Gallery, New York
Ruth and William True, Seattle

iCI (Independent Curators International)
799 Broadway, Suite 205
New York, N.Y. 10003
Tel: 212-254-8200 Fax: 212-477-4781
www.ici-exhibitions.org

Library of Congress: 2008942355
ISBN: 978-0-916365-81-3
Editor: Stephen Robert Frankel
Designer: Gina Rossi
Publication coordinator: Frances Wu Giarratano
Printer: Transcontinental Litho Acme, Canada

Cover: Hank Willis Thomas, *Basketball and Chain* (detail; see page 29)
p. 1: Brian Jungen, *Blanket no. 3* (detail; see page 33)
p. 2: Paul Pfeiffer, *Four Horsemen of the Apocalypse (12)* (detail; see page 48)
Back cover: Matthew Barney, *CREMASTER 4* (see page 17)

Printed in Canada

CONTENTS

FOREWORD AND ACKNOWLEDGMENTS 6
Judith Olch Richards

MIXED SIGNALS 9
Christopher Bedford

UNRULINESS, OR WHEN PRACTICE ISN'T PERFECT 58
Julia Bryan-Wilson

EXCERPT FROM "PERFORMATIVE ACTS AND GENDER CONSTITUTION: AN ESSAY IN 64
PHENOMENOLOGY AND FEMINIST THEORY"
Judith Butler

EXHIBITION CHECKLIST 68

iCI BOARD OF TRUSTEES 71

FOREWORD AND ACKNOWLEDGMENTS

Judith Olch Richards
Executive Director

Despite all that has changed since sexual and social identity became hot-button issues in contemporary art and the discourse on that art throughout the 1970s, '80s, and '90s, one American stereotype still remains particularly entrenched: that of the aggressive, hypercompetitive, emotionally undemonstrative, heterosexual male athlete. *Mixed Signals: Artists Consider Masculinity in Sports* focuses on a variety of works by artists from the mid-1990s to the present who question the notion of the male athlete as the last bastion of uncomplicated, authentic identity in American culture during those decades. In the works presented here, they have appropriated, riffed on, complicated, and variously re-presented athletic imagery, revealing that the male athlete is a far more ambiguous, polyvalent figure in our collective cultural imagination than may be commonly recognized.

The catalogue and traveling exhibition have been made possible through the encouragement, dedication, and generosity of many people. First and foremost, on behalf of iCI's Board of Trustees and staff, I extend our sincere gratitude and appreciation to the curator of the exhibition, Christopher Bedford, who is curator of exhibitions at the Wexner Center for the Arts, The Ohio State University, with whom it has been a pleasure to work. His intelligence, sensitivity, and persistence are clearly visible in his selection of engaging and provocative objects and images on this compelling and timely subject. He has also contributed an absorbing essay that brings us greater insight into the philosophical, aesthetic, and historical aspects of the works in the exhibition, and their significance within contemporary art practice. *Mixed Signals* is an expanded version of his exhibition *Contemporary Projects 11: Hard Targets — Masculinity and Sports* (2008), organized by the Los Angeles County Museum of Art (LACMA), and I express great thanks for their cooperation.

The curator joins me in expressing our gratitude to Julia Bryan-Wilson, director of the Ph.D. Program in Visual Studies, University of California, Irvine, for her essay in the catalogue, which, through her specialized knowledge, provides a valuable perspective on all the works in this exhibition. We are also pleased to have the opportunity to reprint part of an essay by Judith Butler, Maxine Elliot Professor in the Departments of Rhetoric and Comparative Literature, University of California, Berkeley, and we thank her for allowing us to include this text, which serves as an enriching complement to the other essays.

We are also indebted to the lenders who have graciously allowed their works to travel throughout the two-year tour, and to many galleries for their generous assistance. Deserving special acknowledgement in this regard are Giuliano Argenziano, Simon Preston Gallery; Ellie Bronson, Sikkema Jenkins; Chana Budgazad, Casey Kaplan; Jeffrey Deitch; Catriona Jeffries, Catriona Jeffries Gallery; Jennifer Loh, Regen Projects; Mariko Munro and Mari Spirito, 303; Wayne Northcross, The Project; and Shaun Regen, Regen Projects.

We express our deep appreciation to all the participating artists in this exhibition, whose works we are proud to present, and voice particular appreciation to Mark Bradford, Kurt Kauper, Shaun El C. Leonardo, Kori Newkirk, Catherine Opie, Collier Schorr, and Joe Sola for their special efforts.

All of us at iCI convey our deepest thanks to the supporters of this exhibition and catalogue, including the Horace W. Goldsmith Foundation, the iCI Advocates and the iCI Partners, and Agnes Gund, Gerrit and Sydie Lansing, and Barbara and John Robinson. Their generous contributions helped make this project a reality.

On behalf of the curator, I am very pleased to acknowledge the following individuals for their helpful conversation, encouragement, and support throughout the project, direct or indirect: Gillian Bedford; Jennifer Doyle, associate professor of English, University of California, Riverside; Silvia Kolbowski; Robbie LaBelle, Nike Sportswear brand manager; critic Clay Matlin; and Richard Meyer, associate professor of art history and director of the contemporary project, University of Southern California. He also wishes to thank the following staff members at LACMA: Victoria Behner, senior exhibition designer; Laura Benites, assistant registrar; Charlotte Cotton, curator of photography; Carol Eliel, curator of modern and contemporary art; Rita Gonzales, assistant curator of contemporary art; Michael Govan, C.E.O. and Wallis Annenberg Director; Sarah Minnaert, senior exhibitions coordinator; Dorothea Schoene, curatorial assistant; Erin Wright, director of special projects; and Lynn Zelevansky, Terri and Michael Smooke Curator and department head contemporary art. Finally, he expresses his gratitude to Jennifer Bedford for her unflagging support in all things.

Sincere appreciation is due to Gina Rossi for her graphic design of this book, and to Stephen Robert Frankel, the book's editor. It was a great pleasure to work once again with these superb professionals.

iCI's dedicated, knowledgeable, and enthusiastic staff deserves recognition for their work on every aspect of this project, which included securing loans, developing the tour, arranging packing and shipping, and creating this publication. Thanks for this work go especially to Susan Hapgood, director of exhibitions; Rachel May, former registrar; and Frances Wu Giarratano, curatorial associate, as well as to former exhibitions intern Anna Drozda and current exhibitions intern Eriola Pira. I also express my gratitude to Jeffrey Nadler, iCI's director of development and Kristin Nelson, development assistant, for their fund-raising efforts; and to Sarah Thomas, former curatorial assistant; Mary Derr, communications and office administrator; Chelsea Haines, office administrator; Dolf Jablonski, bookkeeper; and Dina Shaulov, former public-relations consultant.

I am pleased to take this opportunity to thank all the institutions that will be presenting this exhibition as it travels; their involvement truly gives it life.

Finally, I extend my continuing appreciation to iCI's Board of Trustees for their steadfast support, enthusiasm, and commitment to all of iCI's activities. They join me in expressing our gratitude to everyone who has contributed to making possible this challenging and gratifying project.

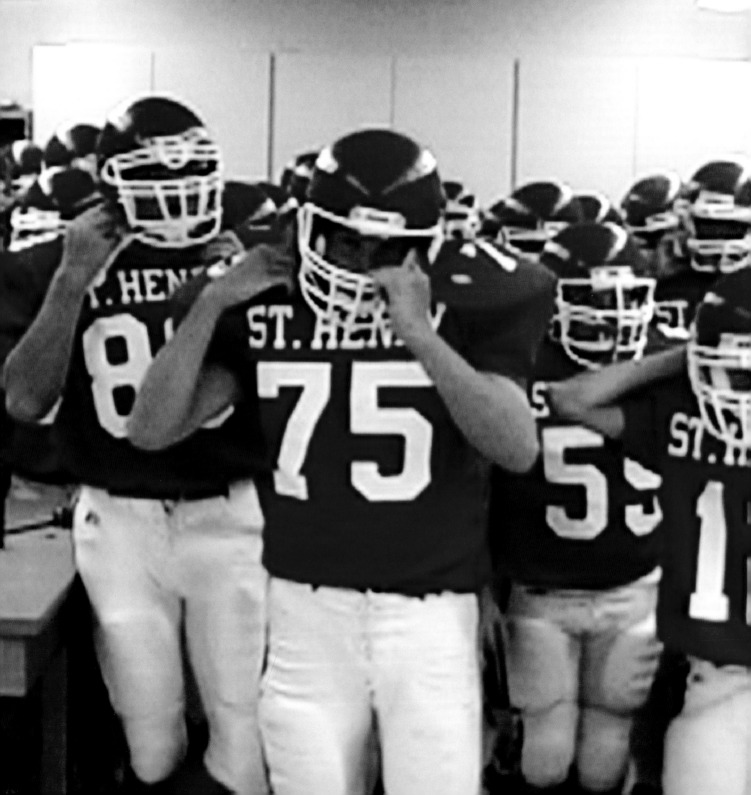

MIXED SIGNALS

Christopher Bedford

INTRODUCTION: FANTASY AND FOOTBALL

"Football players are simple folk. Whatever complexities, whatever dark politics of the human mind, the heart — these are noted only within the chalked borders of the playing field. At times strange visions ripple across that turf; madness leaks out. But wherever else he goes, the football player travels the straightest of lines. His thoughts are wholesomely commonplace, his actions uncomplicated by history, enigma, holocaust or dream." — Don DeLillo[1]

In 2007, Catherine Opie began work on a new series of photographs that examine the culture and imagery of high-school football across the United States. Her coverage of that season resulted in a vast archive of images which she pared down for a solo exhibition at Regen Projects in Los Angeles in spring 2008. That show featured arresting, modestly scaled portraits of individual players, such as *Josh*, *Seth*, and *Davionne*, all 2007, interspersed with photographs that she refers to as landscapes (see pages 10–12, 54), which record the vivid, floodlit theater of football on Friday nights. To initiate this project, Opie had to ingratiate herself with communities of players and coaches largely unfamiliar with her practice as an artist. As Opie notes, her status as a professor of art at U.C.L.A., an institution of nationwide renown and, fortuitously, a football powerhouse, was to these ends extremely useful. Less strategic for Opie's purposes was the prominence of the queer portraits that ushered her into the art-world limelight in the early 1990s, such as *Self-Portrait/Pervert*, 1994 (fig. 1), and which for many people remain synonymous with her identity as an artist.[2]

Opie was, and remains, well aware that in order to continue the high-school football series unimpeded into the 2008 season and beyond, she has to market herself vigilantly. To this end, she has tactically suppressed the identity that had won her such broad acclaim in the art world and instead promoted a normative (though not at all fraudulent) alter ego as a documentary photographer invested in the way community identities are shaped and understood by and through images. Crucial to this process was the Wikipedia entry about her, which, if one does a Web search for "Catherine Opie," is one of the first results to come up. As of September 2008, owing in large part to Opie's own efforts, her biography on Wikipedia is abbreviated and cursory. The first two sentences note matter-of-factly: "Catherine Opie (born 1961) is a North American artist specializing in issues within documentary photography. Throughout her work she has investigated aspects of community, making portraits of many groups including L.G.B.T. community; surfers; and most recently high school football players."[3] A lone portrait of a football player, the sultry *Dusty*, 2007 (fig. 2), is featured on the page, and nowhere is Opie's identity as an artist with a deeply held investment in queer issues made explicit. The words "lesbian," "queer," or "bisexual" do not appear; instead, such unambiguous language is replaced by the far stealthier nomenclature "L.G.B.T."

As I hope this brief but telling anecdote illustrates, there remain profound divisions between the cultural, political, and intellectual interests, imperatives, and convictions that attend the cultural sphere of artists, art historians, curators, and critics, on one hand, and those that anchor and define the cultural orbit of male-dominated amateur

CATHERINE OPIE

opposite: *Josh*, 2007
Chromogenic print
30 × 22 ¼ in. (76.2 × 56.5 cm)
Courtesy the artist and Regen Projects,
Los Angeles

below: *Seth*, 2007
Chromogenic print
30 × 22 ¼ in. (76.2 × 56.5 cm)
Courtesy the artist and Regen Projects,
Los Angeles

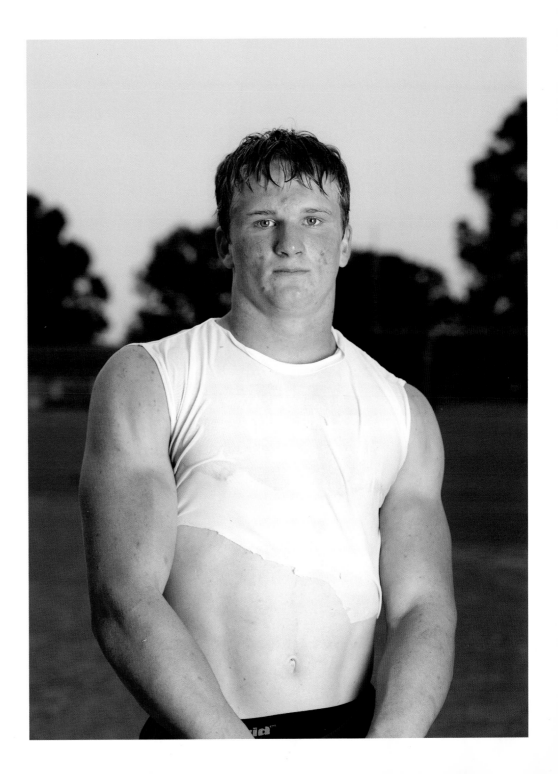

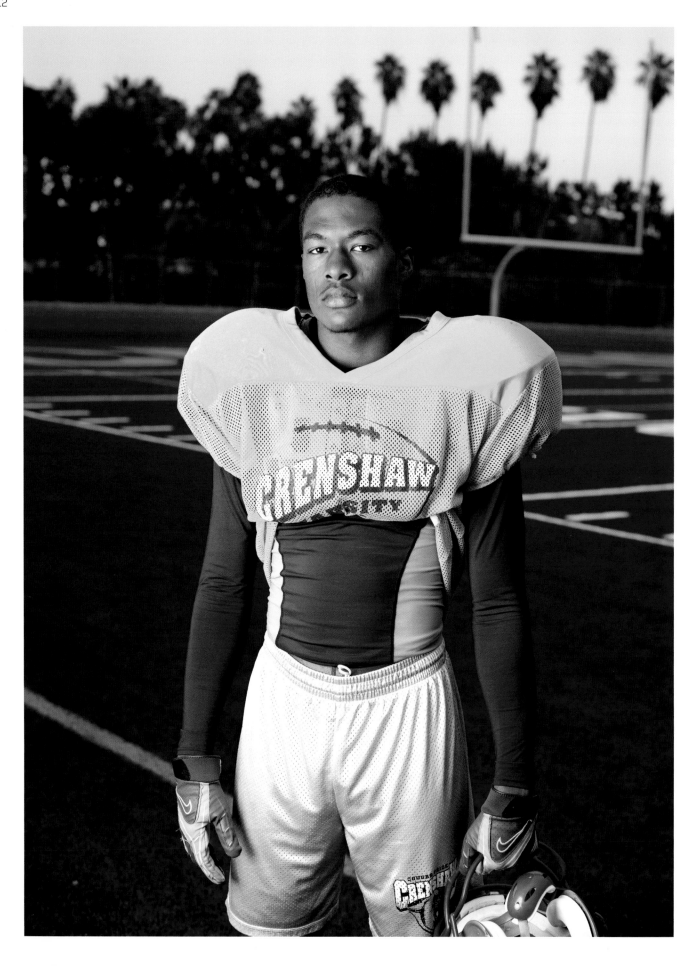

CATHERINE OPIE

opposite: *Davionne*, 2007
Chromogenic print
29 1/2 × 22 in. (74.9 × 55.9 cm)
Courtesy the artist and
Regen Projects, Los Angeles

Fig. 1: Catherine Opie. *Self-Portrait/Pervert*, 1994. Chromogenic print. 40 × 30 in. (101.6 × 76.2 cm). Courtesy Regen Projects, Los Angeles

Fig. 2: Catherine Opie. *Dusty*, 2007. Chromogenic print. 30 × 22 1/4 in. (76.2 × 56.5 cm). Courtesy Regen Projects, Los Angeles

and professional sports in the United States, on the other. It is a division not so much analyzed as assumed, and stronger for it. Imagery that might appear culturally provocative and fertile for analysis in the eyes of a curator (high-capture portraits of adolescent high-school football players taken by an iconic queer photographer, such as *Seth*) might seem nothing short of debased to average high-school football fans in West Texas, a group vividly depicted by H. G. Bissinger in his Pulitzer Prize–winning account of football fanaticism, political conservatism, and racial and gender bigotry, *Friday Night Lights* (1990) (fig. 3). Orthodoxies and conventions of discourse and interpretation exist in the culture of sport just as they exist in the art world, shaping the way we interpret and assign value. As Don DeLillo notes sardonically, "football players are simple folk" who eschew "dark politics of the human mind." Conversely, we typically think of artists as being "Born Under Saturn" (as Rudolf and Margot Wittkower would have it), assumed to embody precisely the reverse condition, excavating the darkest recesses of our collective consciousness to expand the way we conceive of ourselves as agents in the world. Athletes, then, are fundamentally and ideally limited, blind to the forces that shape the project of the artist. These two archetypes, in fact, form a neat dialectic: the pre-analytical male athlete, all nature; and the artist, analytical to a fault, the cultural operator, driven to denaturalize his/her subjects. The object of this essay and the exhibition it accompanies is to scramble this received equation and to mine particular moments of intersection between these historically discrete worlds in a modest effort to trigger new discussions in and between the variegated fields of contemporary art and the vast multi-media spectacle of male-dominated sports.

AN INADEQUATE HISTORY

At some point in the mid-1990s, awareness of masculinity as a "multiform, historically specific social construction"[4] began to take hold in art history and art criticism. As if to mark this shift, in 1994, Maurice Berger, one of the first art historians to look seriously at masculinity in representation, coordinated a special project for *Artforum* called "Man Trouble."[5] The essays commissioned for this project are in their rhetoric and central assumptions very much of their moment. One has the sense, reading Berger's introduction and the essays he commissioned, that something vital is at stake, that these words represent vanguard convictions. For example, Simon Watney, in his essay "Aphrodite of the Future," insists that "gender and sexuality studies must proceed from a respect for the central strands of ambivalence, ambiguity, conflict, and mobility that are so characteristic of gender and sexuality as most of us experience them in practical life."[6] Although Watney's claim may register as somewhat naïve and generalizing in 2009, as recently as 1994 such ideas were uncharted and even radical.

Sport, by virtue of its essentially spectacular character, concentrates the subject of masculinity in representation like almost no other image-based field. Masculine identity as constituted in this theatrical arena, however, is not an explicit subject of analysis in Berger's project, but rather a whisper in the text and a ghost among the accompanying images. A vintage photograph identified by

Fig. 3: Cover of *Friday Night Lights* by H. G. Bissinger (Da Capo Press, 2000)

Fig. 4: Page 76 from *Artforum*, April 1994

an adjacent caption as showing a "football huddle" serves as the wallpaper for reproductions of a homoerotic painting by Attila Richard Lukacs and a wax sculpture of a pert rear-end by Robert Gober (fig. 4), a juxtaposition of background and content that suggests (albeit subtly) that the world of sports is the normative ideological field against which these radical artists must push.[7] Herbert Sussman, writing for the same project in 1994, argued optimistically that "the new thinking reconfigures masculinity as a historical construction rather than an essentialist given,"[8] and the latter position obviously maintained remarkable sway over the way athletes could be understood through images, even in an issue of *Artforum*.

One of the first mainstream American artists to transgress the mute authenticity of the male athlete was Matthew Barney, although the precise terms and implications of this transgression have not been fully examined to date.[9] However, an early essay by Norman Bryson, published in 1995, is unusually straightforward in its treatment of that artist's thematic interests. In it, Bryson notes that "two discourses in particular" shape Barney's work: "sport and medicine," and, more specifically, that "each of these defines the body as a field to be modified and redesigned, acted upon so as to surpass its own limits — a body entirely subject to human will"[10] (see still from *MILE HIGH Threshold: FLIGHT with the ANAL SADISTIC WARRIOR*, 1991; fig. 5). "In Barney's work prior to the present *CREMASTER* series, the sculpted objects make reference to the equipment used to rebuild the athletic body — the gymnasium impedimenta of incline boards, free weights, harnesses, wrestling mats, curl bars. And at the same time, the sculpture refers

to the metabolism of the peak athletic performance . . . Barney's sculptures literally superimpose equipment on metabolism by building apparatus out of biochemical substances"[11] (see *Unit Bolus*, 1991; fig. 6).

As Bryson rightly points out, this operation blurs the distinction between what is inside and outside the body, but we might push this analysis a little further into more specific territory and suggest that such works engage the essentialist/anti-essentialist, nature/nurture debates so central to early feminist discourse. Most fundamentally, Barney's mythic, alchemical allegories argue that gender is not given, it is produced, and that the most exaggerated expression of masculinity — the high-performance athlete — may in fact be the *most* produced of all (even though, ironically, he is understood as the most natural expression of the male condition).[12] As long-time commentator Thyrza Nichols Goodeve noted in the preamble to an early interview with Barney in 1995, "In Barney's universe, hard masculine football-playing bodies are as prone to penetration and transformation as the protean landscape of the fairytale."[13] Mutation and adaptation of the male body in Barney's videos and sculptures has been consistently interpreted according to the highly esoteric, idiosyncratic thematic concepts that shape his work; in other words, the interpretive mode is iconographic and predicated on intentionality. But Barney's work is also highly associative, social, and metaphorical — an iconological field. Bryson declares that in "viewing Barney's work one is enjoined to surrender to its arcane internal laws and fictional premises; you have to leave your own version of the universe at the door."[14] This essay and exhibition insist on

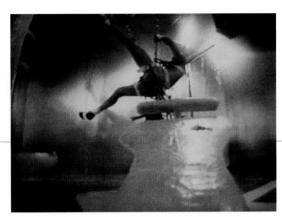

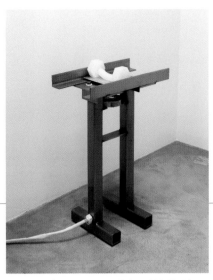

Fig. 5: Matthew Barney. *MILE HIGH Threshold: FLIGHT with the ANAL SADISTIC WARRIOR*, 1991 (video still). ¾-inch color video. 41 mins., 42 secs. Courtesy Regen Projects, Los Angeles

Fig. 6: Matthew Barney. *Unit Bolus*, 1990. Stainless steel rack, cast petroleum jelly dumbbell, electric freezing device. 26 × 18 × 9¾ in. (66 × 45.7 × 24.8 cm). Courtesy Regen Projects, Los Angeles

precisely the opposite: on the value of bringing the arcane, speculative laws of art into direct contact with some of the most stubborn contemporary social ideas.

Due in large part to the pioneering work of feminist and queer theorists, there is now a voluminous and sophisticated literature on masculinity and sport, most of it produced by social scientists, cultural theorists, and historians. And there is, of course, an equally voluminous literature on gender and sexuality in art, ranging from revisionist interpretations of Renaissance female nudes to dense theoretical tracts that reflect the full spectrum of gender and sexual expression in contemporary culture. There is, however, almost no literature on the interrelated subjects of masculinity, sport, and sexuality as subjects within art and art history.[15] That this aspect of masculinity, as formed and expressed in and around sport, has proved elusive to art historians and curators is due in large part to the fact that, until recently, there was not a sufficient critical mass of work to engender such a discussion. In an effort to bring such a discussion to the fore, this essay and exhibition survey some of the most provocative works produced over the last ten years that take masculinity and sport as their central theme.

IN THE COMPANY OF MEN
"You construct intricate rituals which allow you to touch the skin of other men." — Barbara Kruger, 1981

The works included in *Mixed Signals* can be divided into four interrelated thematic categories, the first of which examines a social phenomenon that has become known as homosociality. The most enduring characterization of this complex and elusive term was offered by literary theorist Eve Kosofsky Sedgwick, who used it to describe "the structure of men's relations with other men," specifically examining rituals of male bonding and expressions of affection and desire within male-dominated social networks.[16] All of these practices, she observes, are accompanied more often than not by shared expressions of intense homophobia that are intended to legitimize otherwise transgressive expressions of affection. Sedgwick's analysis is the most cogent, convincing, and historically grounded definition available in conventional scholarly discourse, but her words exist at a profound remove from the phenomena they describe, especially when considered in relation to the bombastic character of contemporary sporting events. A more unorthodox — though no less pertinent or persuasive — characterization of the ethereal, quasi-erotic ties that bind groups of men is offered by novelist Pat Conroy in his fictional account of a young cadet's travails at a military academy in the United States during the 1960s, *The Lords of Discipline* (1980). In the highly imagistic passage that follows, Conroy describes the admiration that the members of the cadre feel for a young cadet named Dante Pignetti:

His body was a work of art forged through arduous repetitive hours with weights. It was not the type of body I admired — the long, fluid muscles of swimmers held more esthetic appeal to me — but it had a magnetic, almost nuclear tension. His upper torso was breathtaking, his chest muscles, his shoulders were all simply extraordinary. . . . In the first month of our plebe year, upperclassmen came from three battalions to see Pig, and the cadre would force

MATTHEW BARNEY

below: *DRAWING RESTRAINT 10*, 2005
(photograph of performance at 21st
Century Museum of Contemporary Art,
Kanazawa, Japan)
Courtesy Gladstone Gallery, New York

opposite: *CREMASTER 4*, 1994 (digital-
image production still)
35mm film with sound
42 mins.
Courtesy Gladstone Gallery, New York

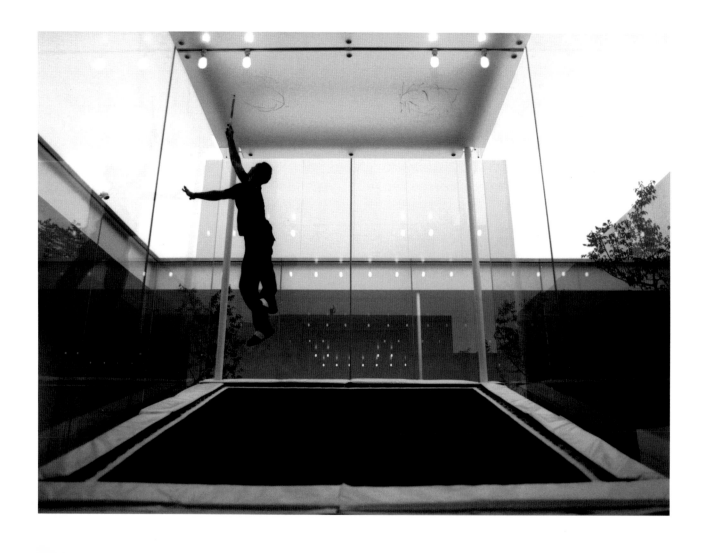

him to strip off his shirt and stand braced as the obscene, uninvited eyes of the upperclassmen examined his already famous physique. . . . They would hit him in the stomach as hard as they could and he would take their best punches. I could not convey how beautiful Dante Pignetti looked to me then, exposed to sunlight, bare-chested, struck by them, admired by them, more than them. [17]

The most striking aspect of this passage is Conroy's unusual grasp of the heady, unnameable admixture of admiration, violence, and desire included under the banner of homosocial behavior.

The ability to give form to these processes may be facilitated by the benefit of firsthand experience, a supposition that holds true in the case of Queens-based multimedia artist Shaun El C. Leonardo (see pages 20–21), whose practice is heavily informed by his experience as a football player at Bowdoin College in Brunswick, Maine. Drawing on those formative years, Leonardo staged a performance at the Los Angeles County Museum of Art on October 8, 2008, that provided the raw footage for his four-channel video projection, *Bull in the Ring,* 2008, and the imagery that anchors a related sculpture with the same title. The eponymous performance featured the artist clad entirely in black and a swarming circle of ten semiprofessional football players all outfitted in white. In Leonardo's own words:

Bull in the Ring is the term used to describe a specific training routine banned from American football on the high school and collegiate levels. In its original form, the team would form a revolving circle, and one player would

be chosen to enter the center of the ring (the matador). One by one, players would be selected by their coach at random (the bull) to charge the player at the center, possibly catching him off-guard to deliver a blow — the object being to have the center player develop alertness by "keeping his head on a swivel" and defending himself from all oncoming offenders. [18]

Most obviously, Leonardo's performance and resulting sculpture and video give brutal metaphorical form to the sacraments of violence that bind competitive teams and separate the weak from the strong, the capable from the incapable, thereby promoting closeness, affection, and camaraderie among men who have demonstrated their virility to one another. Even more radical in the context of football, however, is the idea of relating masculinity to performance, for the very notion of performance strips the drill of its spontaneity, its essential naturalness, and subjects a chance series of athletic events, governed by instinctual, precognitive behavior, to the analytical potential of scripting — quite literally, to the process of representation. By conjoining the ethics of football preparation and the investigative precepts of performance-art practice, Leonardo expands the critical possibilities of both fields.

The conflicted impulse to possess the kind of subjectivity that permits entrance into this rarefied, fraternal world of male violence and camaraderie is at the core of Joe Sola's video *Saint Henry Composition,* 2001 (see pages 22–23). To produce this video, the Los Angeles-based artist inserted himself into the practice sessions of a high-school football team in Ohio, allowing himself to

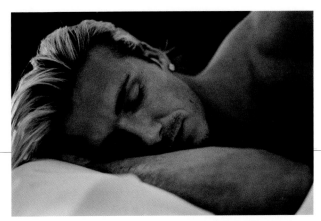

Fig. 7: Sam Taylor-Wood. *David*, 2004. Chromogenic print. 15 ³/₄ × 23 ⁵/₈ in. (40 × 60 cm). Courtesy Jay Jopling/White Cube, London

be variously humiliated and punished at the hands of athletes far younger but also far more agile and "motivated" than he. Images of Sola being bludgeoned and wrestled to the ground in nondescript civilian garb by football players fully equipped for the gridiron is humorous and farcical, but also quite loaded. As Jan Tumlir has astutely noted, the video is built on a series of received oppositions that are by turns revealed, ratified, and undermined:

Insomuch as Saint Henry Composition blithely restages a series of oppositions that continue to divide the U.S. public bitterly, one might assume that it is in fact the harder, rural and generic view that is vindicated. . . . In terms of ideological symbology this could mean the triumph of the "red states" over the "blue states," of "low" sport over "high" culture, of traditional morality over progressive ethics, etc. However, all of the above perceptions are available as well as the "other side," the audience of artworld "insiders" for whom the work is actually made, and this includes the frisson of a potential, but unlikely, defeat at the hands of their (our?) "other."[19]

No other work in this exhibition offers such a nuanced evaluation of the obdurate separation that still persists between sport as a cultural phenomenon and art as a field of inquiry — evidence of the insight to be gained from such moments of messy intersection.

Homosocial desire is not exclusively a physical phenomenon, as Conroy's passage and Leonardo's video and performance work might suggest, but one that can be played out as a purely spectatorial experience. Sam Taylor-Wood's video diptych *3-Minute Round*, 2008 (see pages 24–25), illustrates this possibility vividly. Taylor-Wood's slow, lingering shots of the hulking, exhausted bodies of Russian heavy-weight boxers, Vitale and Vladimir Klitschko, seated on stools in the corner between rounds, demonstrate the startling intimacy of concentrated close-ups, and the exaggerated level of access to public figures provided by television. The insistent slowness of the action and the complete absence of violence — boxing's defining trait — expose the bodies of the two boxers to alternative modes of consumption — specifically, to expressions of desire *not* tethered to the discourse of boxing, and without the alibi of investment in the progress of a game or match to justify or excuse the viewer's impulse to look. By slowing down the action but, vitally, not altering the image-feed in any way, Taylor-Wood suggests that such confused (even contaminated) desires and impulses are always present, and, in doing so, prompts the spectator to confront and codify those sensations. In a conceptually related work, *David*, 2004 (fig. 7), a video portrait of soccer star David Beckham sleeping, Taylor-Wood stresses the soft sensuality of her subject, and suggests that he inspires reverence not only for his brilliance on the field: perhaps more important, the image conveys the variety and power of desire that this icon inspires in his fans, ranging from simple lust to the type of unspoken homosocial desire that accompanies the admiring gaze of the male fan.

MATERIAL EVIDENCE

Cécile Whiting, in her study of Pop art in Los Angeles during the 1960s, examines at length the ways in which social identities are constructed and maintained through the manipulation of surfaces. Commenting on British painter

(continued on p. 26)

SHAUN EL C. LEONARDO

Bull in the Ring, 2008 (photograph of
performance at Los Angeles County
Museum of Art, October 2008)
Courtesy the artist

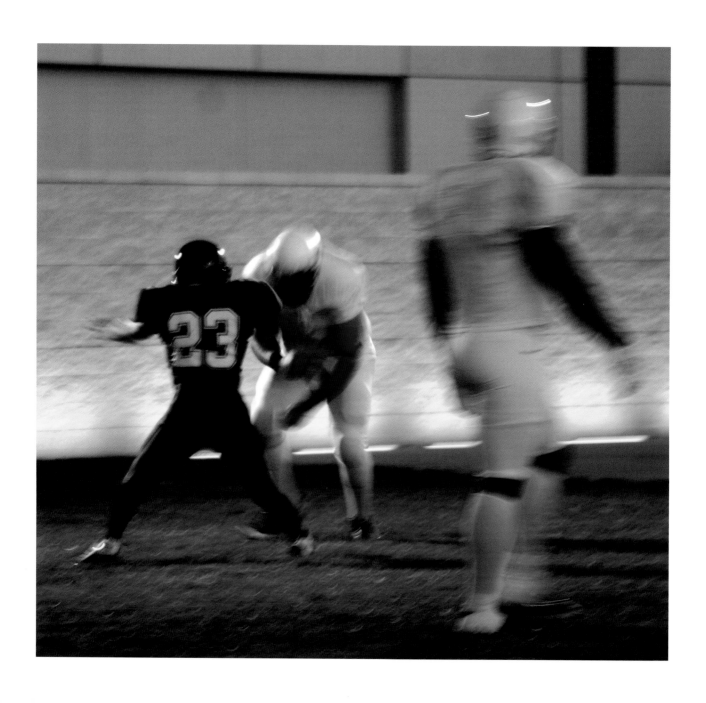

SHAUN EL C. LEONARDO

Bull in the Ring, 2008 (installation view at Los Angeles County Museum of Art, 2008)
Polycarbonate football helmets, latex prosthetics, Styrofoam heads, mono-filament, and PVC pipe ring
Approx. 96 × 96 × 96 in. (243.8 × 243.8 × 243.8 cm)
Courtesy the artist and Rhys Mendez Gallery, Los Angeles

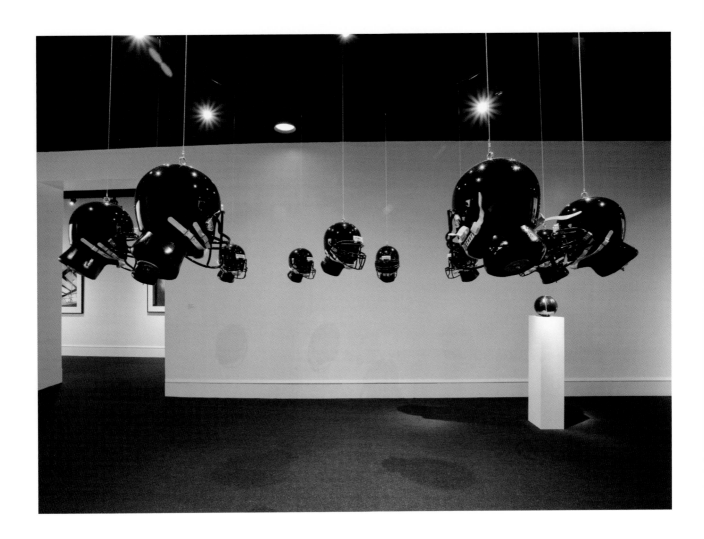

JOE SOLA

below and opposite: *Saint Henry
Composition*, 2001 (video stills)
Single-channel video with sound
5 mins., 7 secs.
Courtesy Bespoke Gallery, New York,
and the Wexner Center for the Arts,
Columbus, Ohio

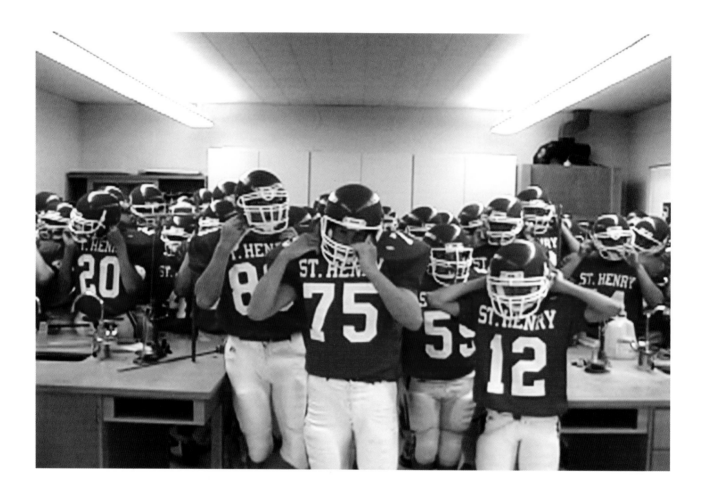

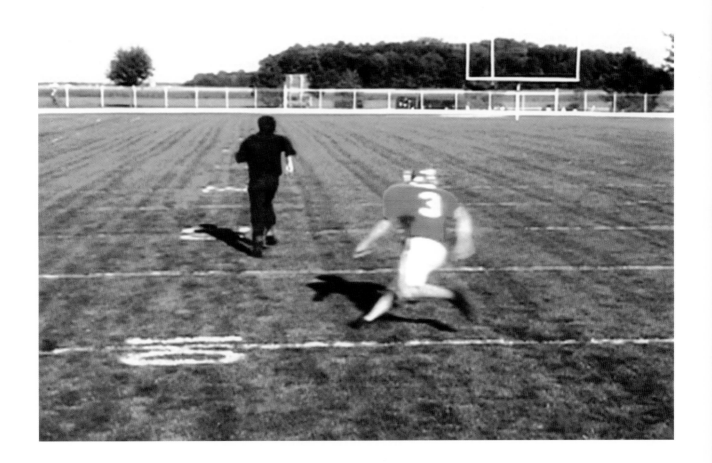

SAM TAYLOR-WOOD

below and opposite: *3-Minute Round*, 2008
(digital-image production stills)
Two-channel video
3 mins.
Courtesy Jay Jopling/White Cube,
London

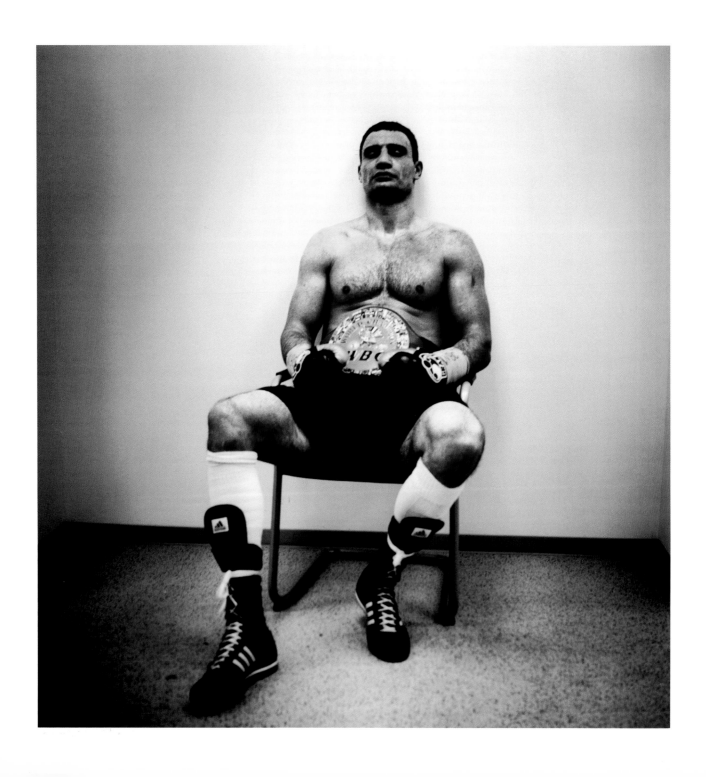

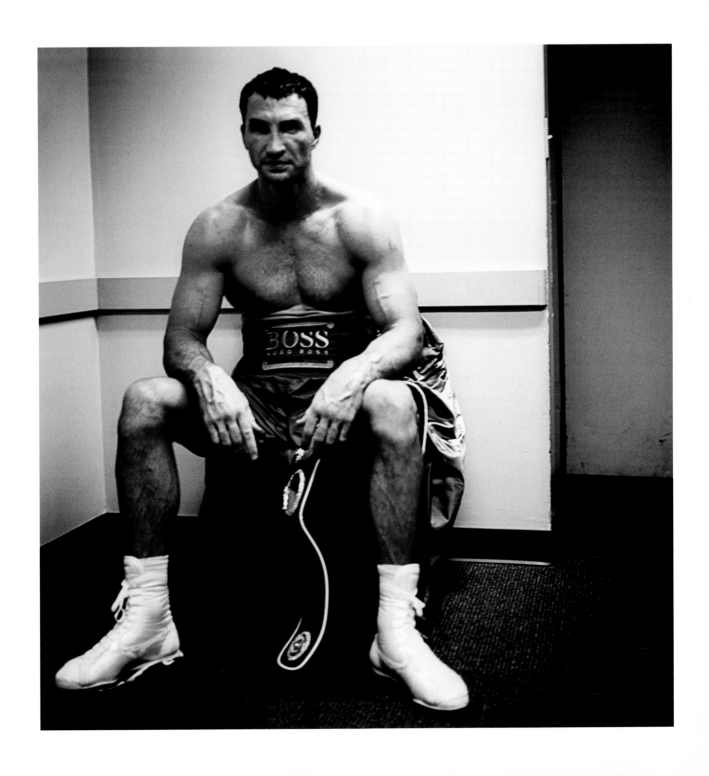

David Hockney, she observes that "Hockney's surface artifice, so reminiscent of the fashionable flourish with which the artist defined himself in public, and the tropical colors, so different from Ruscha's bold palette, engaged mid-twentieth-century modernism with a queer eye. At the same time surface artifice gave material form to a fantasy about a gay lifestyle in the open, outdoors, in the light of day."[20] What is notable in this passage is Whiting's commitment to the idea that surfaces alone can function as repositories of social identity and, perhaps more important, as sites for the deliberate reconstruction of identity.

Like the conventions of aggressive, overtly heterosexual, hyper-competitive, emotionally remote behavior that guide the male athlete's conduct on the wrestling mat or football field, the elaborate paraphernalia that clothe athletes and frame sporting events are so commonplace in contemporary culture that they have become invisible. Accordingly, little attention is paid to the possibility that the commercial artifice of uniforms and brands inflects the way we understand gender and racial identity in athletic contests. Hank Willis Thomas, Kori Newkirk, Brian Jungen, Marcelino Gonçalves, and Kurt Kauper (see pages 28–37) all take up this question, proposing that if identities are established in part through artifice, then they can be remade through the manipulation of those surfaces.

Of these artists, Thomas deals most explicitly with the insidious (and ubiquitous) ways in which commercial branding is tied to race in sports marketing, connecting this phenomenon to the way eighteenth- and nineteenth-century slaves "were branded as a sign of ownership."[21]

Scarred Chest, 2003, for example, is a starkly rendered photograph of a man's torso, his lines so taut and defined that his anatomy looks sculptural, recalling the exaggerated idealism of a Greek cuirass. The image dominates the frame so that we can't see the man's face, with the focus instead on his commercial identity, made explicit by the embossed Nike swooshes that are "branded" (using Photoshop) across his armor-like pectorals. Just as emphatic in its rhetorical symbolism, Basketball and Chain, 2003, suggests that black men, revered for their abilities on the basketball court, are concomitantly limited by the social and racial essentialism that underlies such reverence.

Newkirk addresses similar questions of black masculinity in commercial sports culture, but does so more obliquely and poetically. His wall-bound sculpture, Closely Guarded, 2000, consists of two lustrous, nickel-plated basketball hoops connected by strings of pony beads and synthetic hair woven together to make a basketball net. Newkirk's work is concerned with the unspoken politics of inclusion and exclusion that govern this "closely guarded" sport. Basketball is an activity dominated at every level by black men, but only the "right" kind of black man is admitted to the fraternity. Newkirk's use of beads and artificial hair are metonyms for the wrong black body: the ornate, feminized — contaminated — presence scorned in the locker room.

Jungen, a Canadian artist who is a member of the Dane-Zaa Nation of North British Columbia, has said that his work addresses the "paradoxical relationship between a consumerist artifact and an 'authentic' native artifact" as a way of staging a sharp critique of the way consumerism has occluded and ultimately usurped native traditions in the

context of Western capitalism.[22] However, his work also *claims* the products of Western commercialism as new "native" artifacts, and, in the process, he remakes the ingrained identity of those materials. *Blanket no. 2* and *Blanket no. 3*, both 2008, from Jungen's latest body of work, continue his exploration of consumer products, in this case N.F.L. and N.B.A. jerseys, which he has combined and woven to resemble Native American trade blankets, obscuring names and team colors to make a soft sculpture that registers not only the globalization of commerce but the mobility of identity.

While Thomas, Newkirk, and Jungen are concerned with reconstituting athletic identity by physically manipulating sports equipment and regalia, painters Gonçalves and Kauper are each interested in the surface of images and in the spectatorial experience. This is particularly evident in Gonçalves's provocatively titled oil-on-panel painting *Receiver*, 2002, which captures the likeness of a jubilant young football player on the sidelines, his mouth in a wide-open smile. Here, Gonçalves uses careful, delicate brushstrokes to compose paintings that deal obliquely but insistently with male homosexuality and its relationship to the culture of football. The synthetic character of the painting is obviously not intended to evoke the way we see the world in the truest optical sense, but is, rather, an expressive tool or interference layer employed to capture the way our own identity and predilections cause us to see the world in code, to read surfaces for markers of the familiar and the unfamiliar. Like Hockney's, Gonçalves's paintings of men are not explicit in content; rather, sexual identity and desire are registered as aspects of surface reality and of our perception of it — in short, we perceive and understand only what we are prepared and equipped to see. Kauper's *Study for "Bobby #3,"* 2006, in contrast, uses nudity as a way to denaturalize the figure of the revered male athlete, in this case, the former Boston Bruin great, Bobby Orr. Bobby is presented naked, striding confidently toward the viewer, his easy smile an essay in the self-assurance that comes with athletic prowess. The dissonance between the iconicity of Orr as public figure seen most often clad in pads on a hockey rink, and Kauper's disarming rendering of "Bobby" stripped of those public trappings, makes clear the vital role played by context in determining social identity; remove the social attributes of the professional athlete and one is left with a very different image.

BRING THE DRAMA
"One might wonder if the boxing match leads irresistibly to this moment: the public embrace of two men who otherwise, in public or in private, could never approach each other with such passion." — Joyce Carol Oates[23]

Male-dominated sporting spectacles very often entail demonstrations of virility that culminate in the surrender or at least submission of one man (or men) to another man (or group of men). The thinly veiled sexual valence of this very basic process was not lost on boxer Muhammad Ali's inimitable and irrepressible proselytizer, Bundini Brown, who summed up the recipe for success in the ring with characteristic, syncopated flair: "You got to get the hard-on, and then you got to keep it. You want to be careful not to lose the hard-on, and cautious not to come."[24] Very few sports carry the erotic charge or embody the

(continued on p. 38)

HANK WILLIS THOMAS

Scarred Chest, 2003
Lightjet print
30 × 20 in. (76.2 × 50.8 cm)
Courtesy the artist and Jack
Shainman Gallery, New York

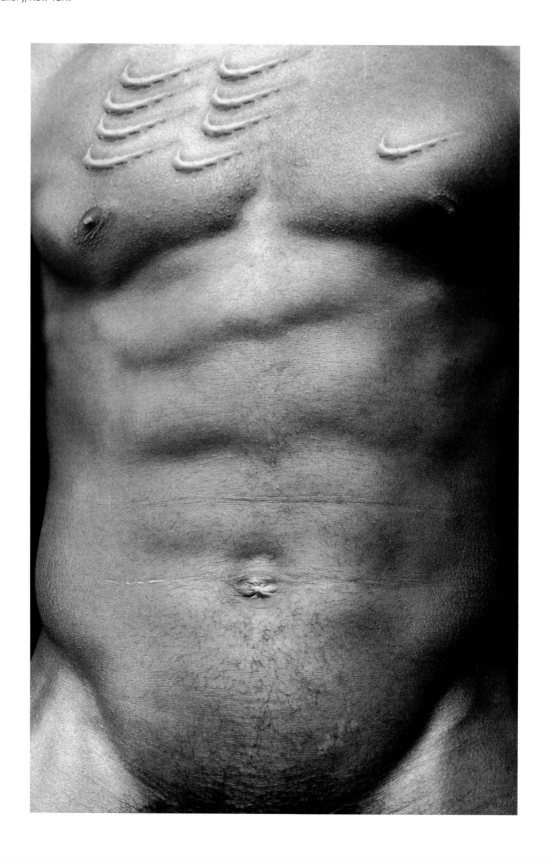

HANK WILLIS THOMAS

right: *Something to Stand on:
The Third Leg*, 2007
Polyurethane coating on MDF
49 × 41 × ¾ in. (124.5 × 104.1 ×
1.9 cm)
Courtesy the artist and Jack
Shainman Gallery, New York

below: *Basketball and Chain*, 2003
Lightjet print
30 × 20 in. (76.2 × 50.8 cm)
Courtesy the artist and Jack
Shainman Gallery, New York

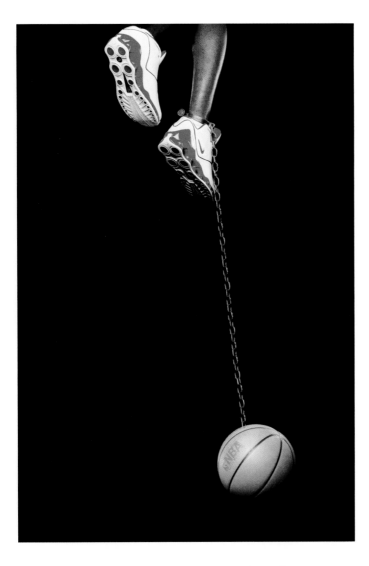

KORI NEWKIRK

Closely Guarded, 2000
Plastic pony beads, artificial hair,
and metal basketball hoops
120 × 48 × 24 in. (304.8 × 121.9 ×
60.9 cm)
Collection of Lois Plehn

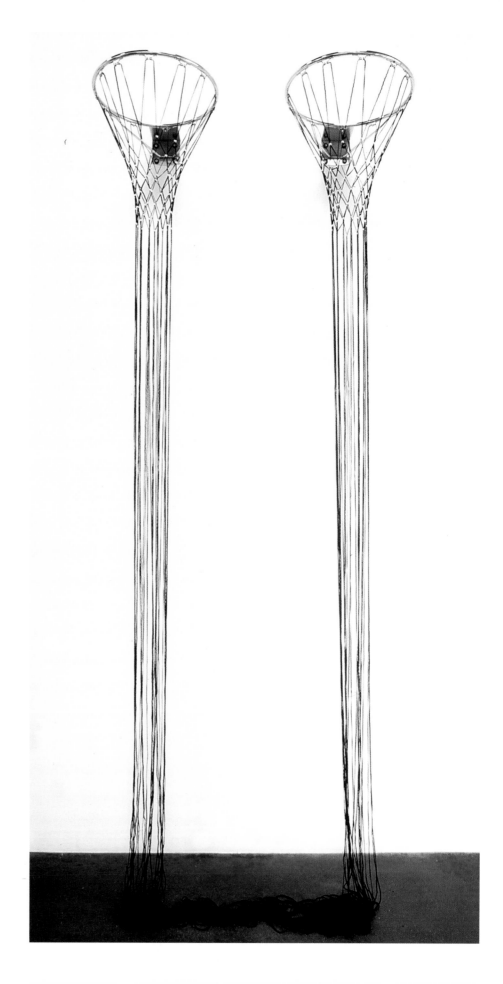

BRIAN JUNGEN

right: *Prototype for New Understanding #12,*
2002
Nike Air Jordans
23 × 11 × 12 in. (58.4 × 27.9 × 30.5 cm)
Collection of Ruth and William True,
Seattle; courtesy Catriona Jeffries
Gallery, Vancouver

below: *Michael,* 2003
Screen print on powder-coated
aluminum, 10 boxes
Installation dimensions: 34 × 44 × 33 in.
(86.4 × 111.8 × 83.8 cm)
Rennie Collection, Vancouver

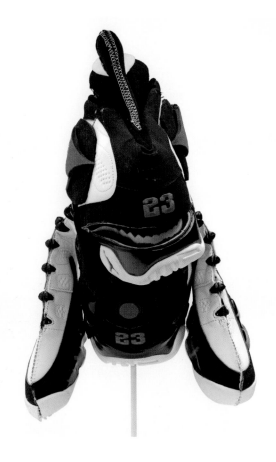

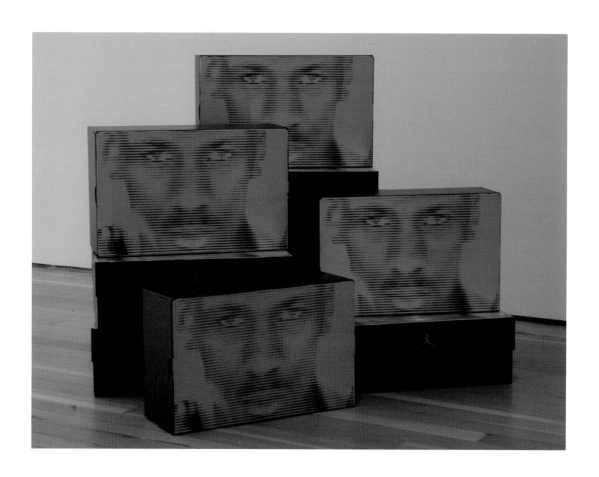

BRIAN JUNGEN

Blanket no. 2, 2008
Professional polyester sports jerseys
53 × 51½ in. (134.6 × 130.8 cm)
Courtesy the artist and Casey Kaplan
Gallery, New York

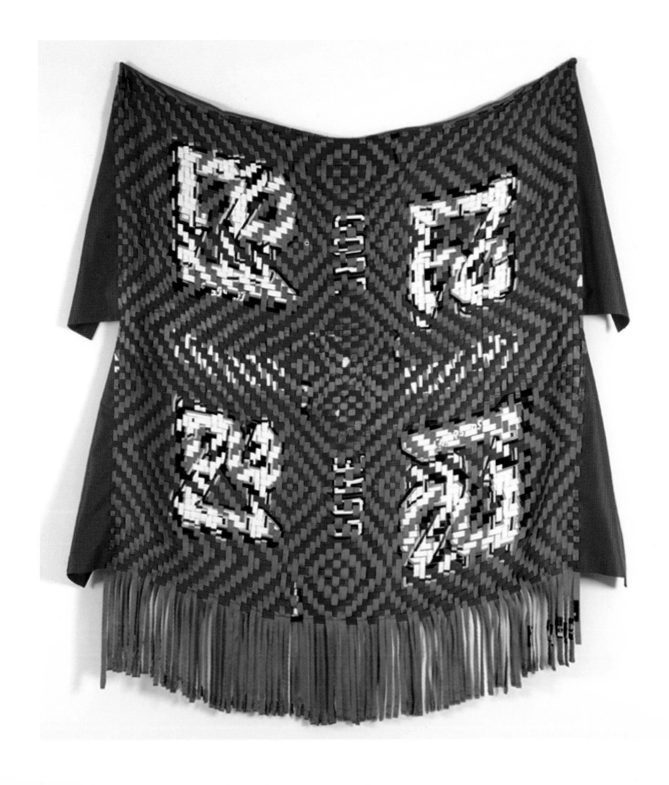

BRIAN JUNGEN

Blanket no. 3, 2008
Professional polyester sports jerseys
54 × 47 in. (137.2 × 119.4 cm)
Courtesy the artist and Casey Kaplan
Gallery, New York

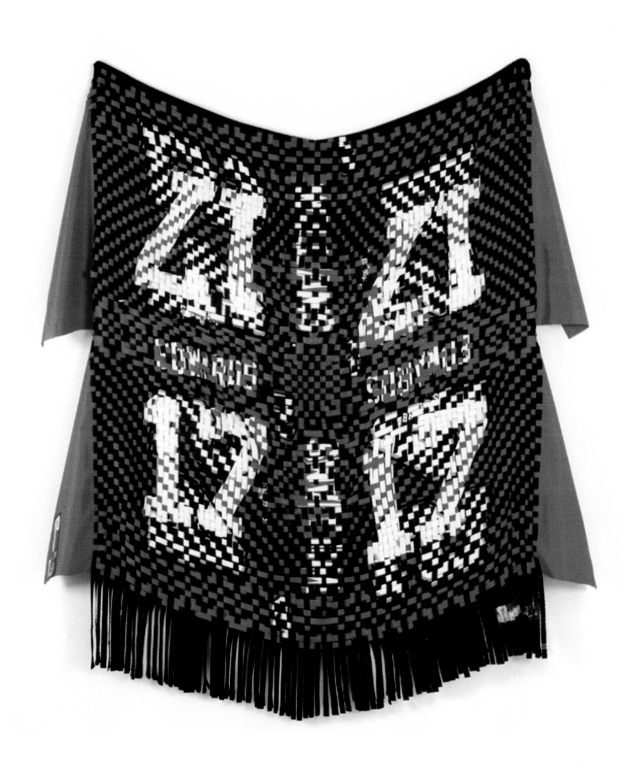

MARCELINO GONÇALVES

below: *Receiver*, 2002
Oil on panel
12 × 12 in. (30.5 × 30.5 cm)
Collection of Marcia Goldenfeld Maiten
and Barry Maiten, Los Angeles

opposite: *Untitled*, 2006
Oil and graphite on panel
33 × 24 in. (83.8 × 60.9 cm)
Collection of the artist; courtesy
James Harris Gallery, Seattle

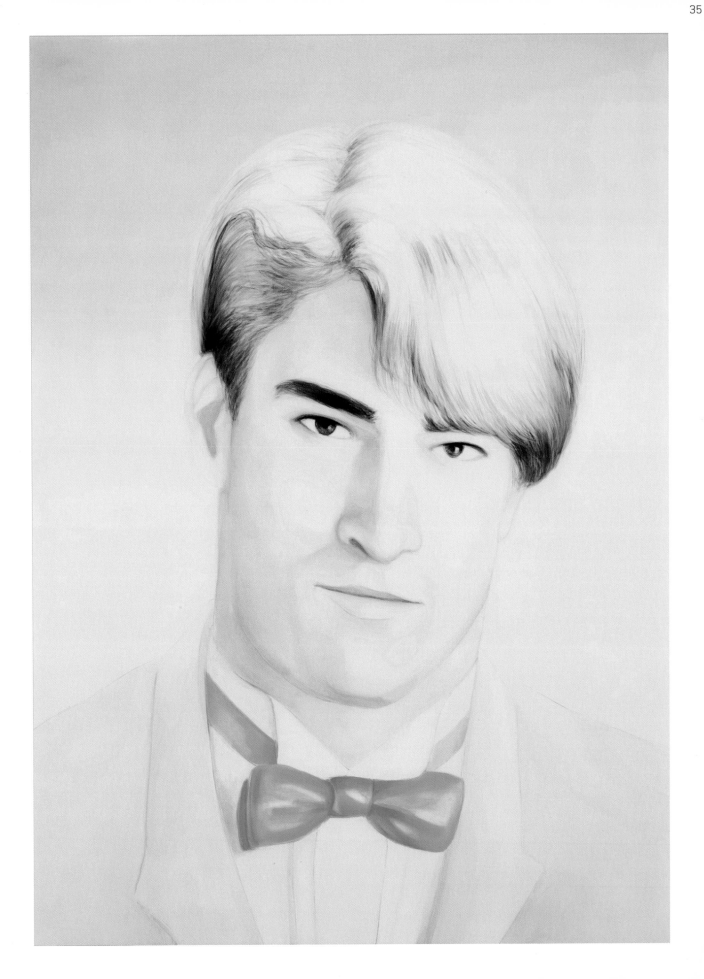

KURT KAUPER

Study for "Bobby #3," 2006
Graphite on paper
40 × 26 in. (101.6 × 66 cm)
Courtesy Deitch Projects, New York

KURT KAUPER

Study for "Shaving Before the Game,"
2007
Graphite on paper
41 × 26 in. (104.1 × 66 cm)
Courtesy Deitch Projects, New York

performative, theatrical dimension of gender so precisely and dramatically as boxing, a sport that takes place quite literally on a stage. It is, as Joyce Carol Oates has noted, an activity of unrivaled brutality but also one of unguarded intimacy. In a disquieting series of photographs collectively known as *Memoirs of Hadrian,* 2008 (see pages 40–43), Lyle Ashton Harris plays a battered pugilist in varying stages of bewilderment and disorientation, clad in a white jockstrap and oversize boxing gloves that threaten to weigh down his slender arms. That this is unambiguously a masquerade is driven home by the absence of an opponent and the consequent implication that the damage Harris appears to have absorbed may have been self-inflicted.

Far less brutal but no less performative is Mark Bradford's video *Practice,* 2003 (see page 44), in which Bradford shows himself dribbling a basketball with frenetic intensity on an unspecified urban court, clad in a cumbersome, sculptural, purple-and-yellow gown that severely limits his range of motion, causing him to trip over himself and drop the ball over and over again. The opposition between Bradford's restrictive attire and his apparently athletic, capable figure raises pertinent questions about how a tall black man should perform on the court. As Bradford prowls around the court concentrating on his dribble, taking the occasional tumble, and even growling with mock ferocity into the camera, one assumes that this is a simple parody of cultural stereotypes intended to expand the range of possible subjectivities embodied by a lithe black man — that is, until Bradford pauses, then shoots and sinks a long-range shot, in a single instant unraveling this simple, critical reading and leaving the interpretative field determinedly open.

Whereas Bradford opts to occupy the normative role of victor at the end of a practice routine that embodies anything but normativity, Marco Rios, in his pantomime-like performance titled *Moving Equilibrium,* 2006 (see pages 46–47), staged in a modest university gymnasium, chooses choreographed failure instead.[25] The stocky artist, clad in a white T-shirt and black spandex unitard, attempts to hoist a jumbo-size yellow level over his head. Accompanied by the cacophonous sound of drums, a roaring crowd, and a ring-girl, and attended by a vigilant referee who doubles as a cheerleader, Rios ultimately fails in his task, tumbling to the ground and dropping the level, upending the fundamental precepts of the sporting event by making a spectacle of an aimless task that culminates in abject failure. Although Bundini Brown would likely have chastised Rios for failing to maintain his "hard-on," eminent gender theorist Judith Butler might well applaud Rios's willingness to objectify his own loss of virility and his attempt to disavow the "accomplishment" of conventional masculinity.[26]

Paul Pfeiffer (see pages 48–49) has examined the magnetism of sport as a form of public theater in a series of photographs titled *Four Horsemen of the Apocalypse,* drawn from the archives of the National Basketball Association. *Four Horsemen of the Apocalypse (12),* 2004, shows a player clad in a glittering white uniform, stripped of all brands and insignias, suspended in midair, his body awkwardly contorted as the eyes of the sprawling crowd are trained on his body. He is the epicenter of this frozen moment, a fact emphasized by Pfeiffer's decision to eliminate from the image the other players around him, focusing the viewer's attention on the man's body, not on the

player's involvement in a professional basketball game. As Pfeiffer has said: "I've been selectively appropriating these images and manipulating them to remove all the contextual detail, so that what remains is not an absent figure but an intensified figure by virtue of the fact that you are lacking some aspects of a context to place it in."[27] The results of this process are uncanny, irrational images that do not accord with the narrative logic of conventional sports photojournalism (a mode of image-making that relies heavily on context to provide meaning); instead, these photographic works focus our attention on decontextualized, kinetic bodies in the midst of performance, untethered from familiar narratives and laws of interpretation.

THE LAST CASTLE

"On a Friday night, a set of spindly stadium lights rises to the heavens to so powerfully and so briefly, ignite the darkness." — H. G. Bissinger[28]

Despite the best efforts of critically minded artists, theorists, and historians, the drama, blind adulation, and modern tribalism that attend the theater of amateur and commercial sports makes this world remarkably impervious to revision and transgression. Accordingly, the final section of this essay addresses works that acknowledge and grapple with this difficulty. Photographers Catherine Opie and Collier Schorr (see pages 10–12, 51–54, 72) share an uncomplicated attraction to the insular world of male-dominated sports. In many instances, the power of their respective practices is derived not from any critical distance that might be maintained between themselves and their subjects, but, on the contrary, from their mutual willingness to be seduced by, even to surrender themselves to, the subjects that occupy those worlds.

Although Schorr is perhaps best known for her photographs of adolescent wrestlers, she has also produced a body of work that examines the equally intense and hermetic world of bareback rodeo riders. In a portfolio of photographs commissioned by the *New York Times Magazine* in 2007 to accompany an article about Wrangler jeans entitled "Branded," Schorr recorded riders posing, praying, dressing, and lying in bed, in each case displaying a keen eye for the expected bravado and the unguarded moments, as well as the instances where the two coexist (such as *Anonymous Cowboy*, 2008).[29] Paul Pfeiffer, describing his experience as a photographer at a basketball game, has noted that "it's extremely difficult to sit in the arena as an artist with a camera and be dispassionate and be removed from the emotional intensity that's going on. At a certain point, especially if it was a good game, I just wanted to put down the camera and just watch. How do they do that?"[30] Similarly, there is a careless romance that Schorr captured in her portrayals of the bareback riders, an approach to representation that flies in the face of the rigidly critical posture adopted by most of the artists whose work is included in this exhibition. In Schorr's own words,

I loved shooting at a rodeo because I knew I was watching a cliché. The compulsion on my part is to get as far underneath the costume as possible and yet, as a viewer/voyeur I am seduced by the mythology; the cowboy as wanderer, risk taker, performer of feats of incredible danger. They

(continued on p. 50)

LYLE ASHTON HARRIS

Memoirs of Hadrian #38, 2008
Pigment print on satin paper
34 × 30 in. (86.4 × 76.2 cm)
Courtesy Adamson Gallery/Editions,
Washington D.C.

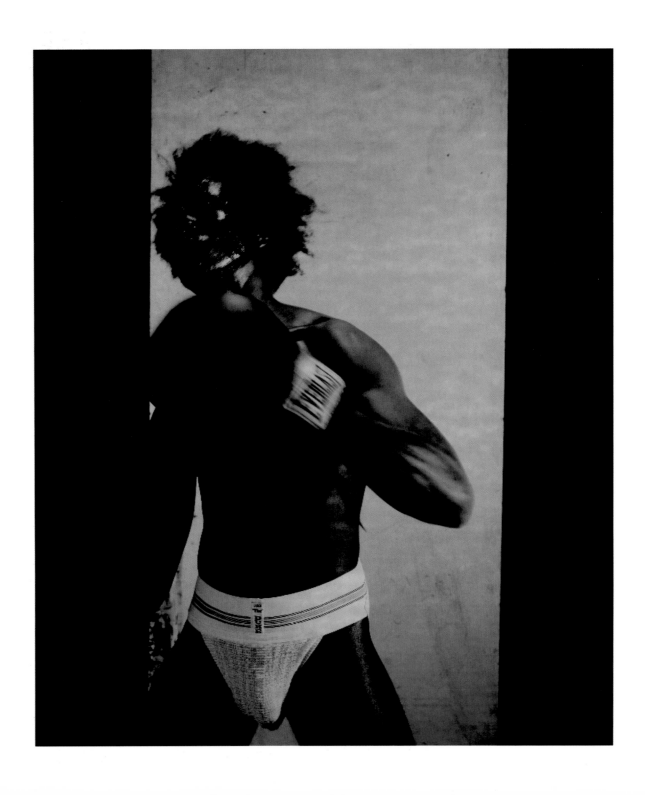

LYLE ASHTON HARRIS

Memoirs of Hadrian #1, 2008
Pigment print on satin paper
34 × 30 in. (86.4 × 76.2 cm)
Courtesy Adamson Gallery/Editions,
Washington D.C.

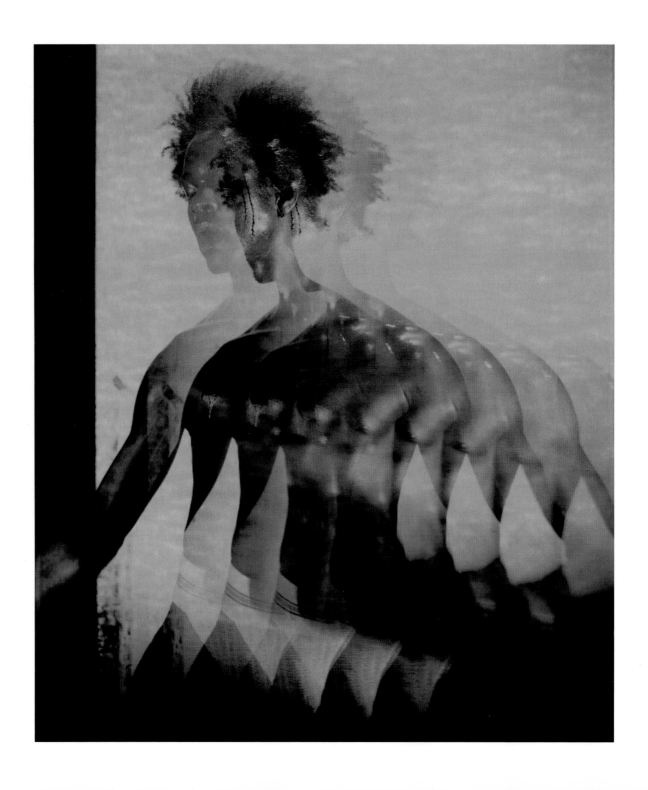

LYLE ASHTON HARRIS

Memoirs of Hadrian #31, 2008
Pigment print on satin paper
34 × 30 in. (86.4 × 76.2 cm)
Courtesy Adamson Gallery/Editions,
Washington D.C.

LYLE ASHTON HARRIS

Memoirs of Hadrian #39, 2008
Pigment print on satin paper
34 × 30 in. (86.4 × 76.2 cm)
Courtesy Adamson Gallery/Editions,
Washington D.C.

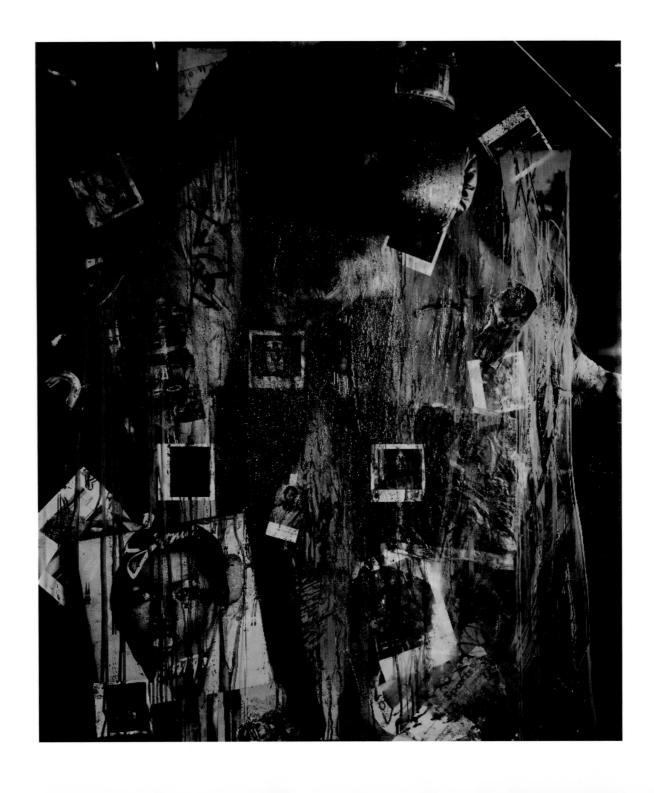

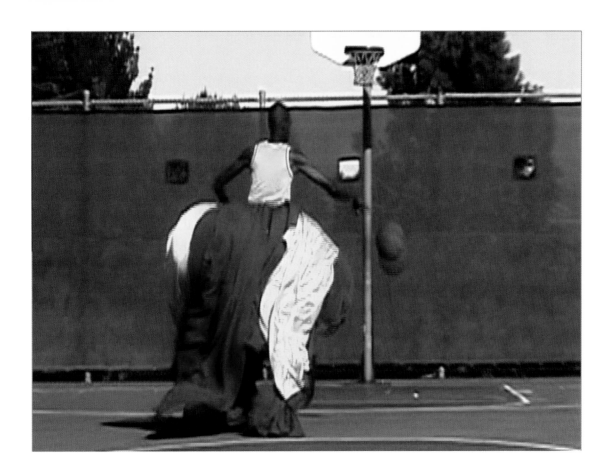

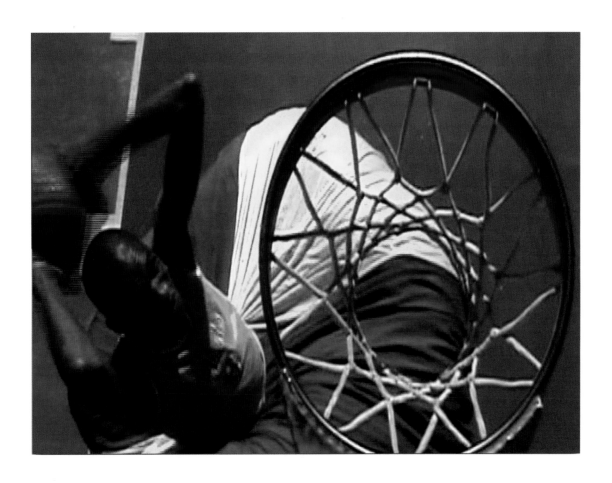

MARK BRADFORD

opposite: *Practice*, 2003 (video stills)
Single-channel color video with sound
3 mins.
Courtesy the artist and Sikkema Jenkins
& Co., New York

below, left to right: *Double Speak* and *Kobe
I Got Your Back*, both 2008 (installation
view at Los Angeles County Museum of
Art, 2008)
Papier-mâché, wire, soccer balls, and net-
ting; papier-mâché, wire, and basketball
Courtesy the artist and Sikkema Jenkins
& Co., New York

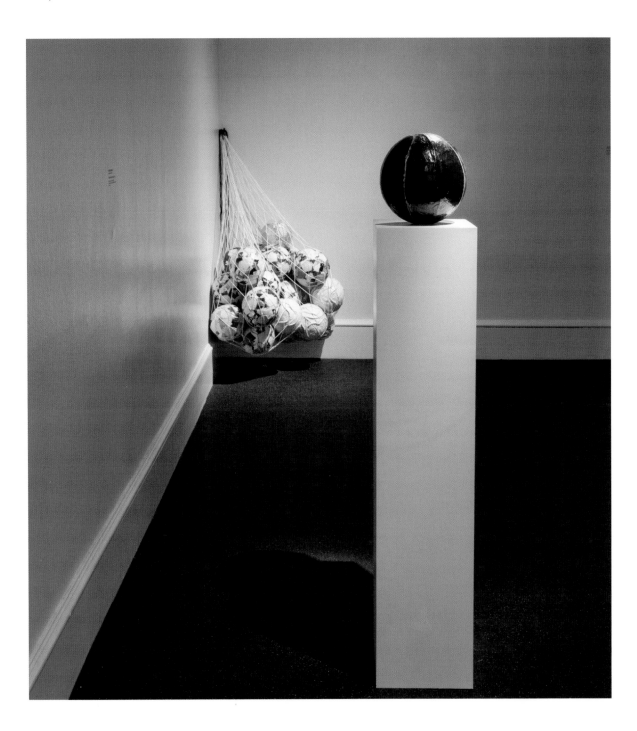

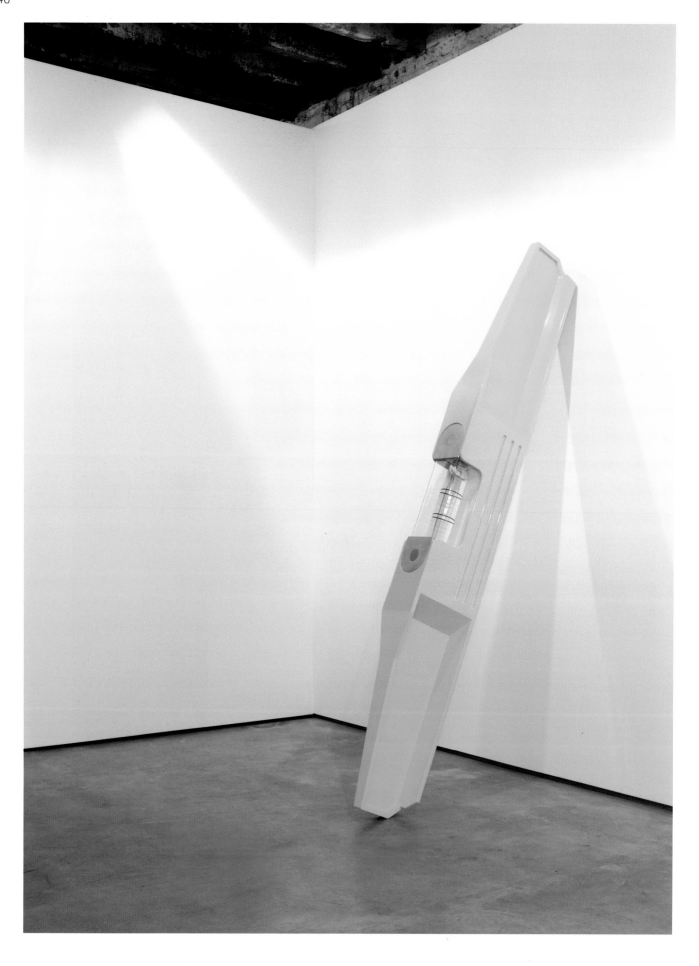

MARCO RIOS

opposite: *Moving Equilibrium (Level Sculpture)*, 2006 (installation view)
MDF particle board, aluminum, glass, wood, Plexiglas, enamel, and water
96 × 7 1/4 × 13 1/4 in. (243.8 × 18.4 × 33.7 cm)
Collection of Eileen Harris Norton, Santa Monica

below: *Moving Equilibrium*, 2006 (video stills of performance at Crawford Hall Gym, University of California, Irvine, May 11, 2006)
Single-channel video with sound
5 mins., 3 secs.
Courtesy the artist and Simon Preston, New York

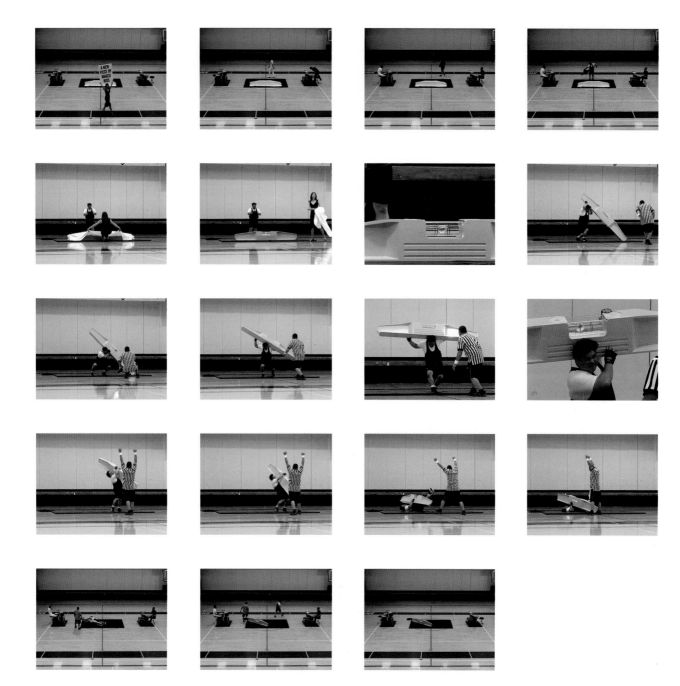

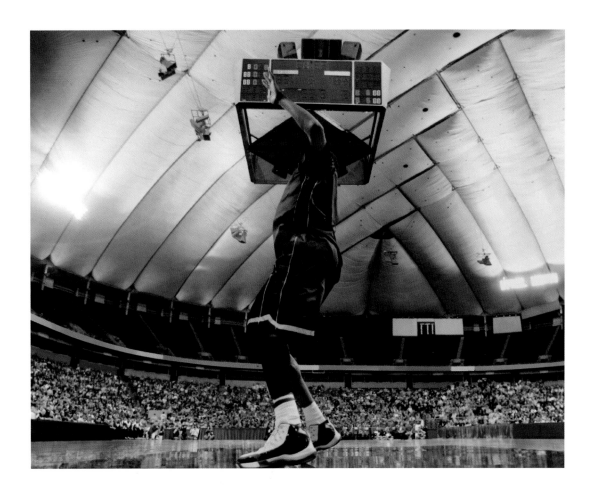

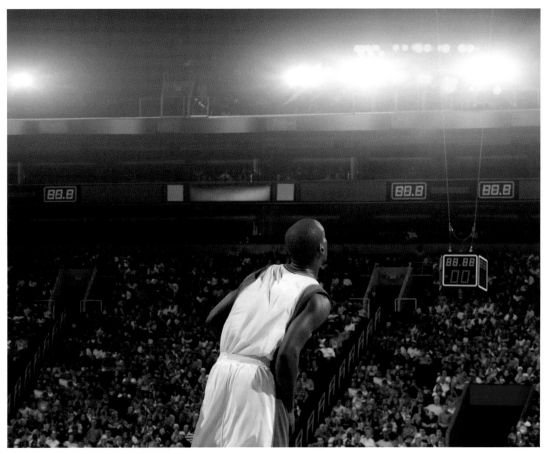

PAUL PFEIFFER

opposite, above: *Four Horsemen of the Apocalypse (28)*, 2007
Fujiflex digital chromogenic print
48 × 60 in. (121.9 × 152.4 cm)
Courtesy the artist and The Project, New York

opposite, below: *Four Horsemen of the Apocalypse (12)*, 2004
Fujiflex digital chromogenic print
48 × 60 in. (121.9 × 152.4 cm)
Courtesy the artist and The Project, New York

below: *John 3:16*, 2000 (installation view)
DVD, L.C.D. screen, mounting arm and bracket
2 mins.
Installation: approx. 7 × 7 × 36 in.
(17.8 × 17.8 × 91.4 cm)
Courtesy the artist and The Project, New York

COLLIER SCHORR

opposite: *Anonymous Cowboy*, 2008
Archival pigmented ink print on cotton-
rag paper
27 × 21 in. (68.6 × 53.3 cm)
Courtesy the artist and 303 Gallery,
New York

function as entertainers and in that way they have as much in common with ranch workers as they do opera singers. They understand their role within spectacle and like all performers they thrive on the attention of photographers. More than any other group I've photographed, one can't get away from the sense of Americans attached to the rodeo. I've spent so much time photographing in Europe and I felt like a tourist in their midst.[31]

While the value of Barney's work, for example, may lie in his methodical dissection of normative masculinity, the radicality of Schorr's work, in contrast, may rest principally in her refusal of such critical mechanisms, and in her willingness to bring her own subjectivity into such close proximity to that of her subjects and in the process to declare herself "the Other."

A similar process is at play in Opie's ongoing photographic series examining the culture of high-school football in the United States. *Football Landscape #1 (Fairfax vs. Marshall, Los Angeles, CA)*, 2007 captures the tension on a floodlit field, presumably on a warm autumn night in Los Angeles, just before the ball is snapped and the tenuous stasis of the field gives way to the mayhem of the next play. The posture of the two players in the foreground is rigid and concentrated, the defensive back watching the receiver like a hawk as the receiver in turn waits for the ball to be snapped. Like most of the photographs in this series, the image cuts against the grain of sports journalistic photography, eschewing the defining moment in favor of the incidental. For the modestly scaled portraits, Opie asked the players to think of their most memorable moment play-

ing football, and in images like *Josh,* 2007 (see page 10), Opie manages to capture the tentatively constituted self-image of her teenage subjects as they summon their dearest sports fantasy.[32] Not quite adult men, but certainly not boys anymore, the young men in these portraits often appear hesitant about themselves, aware of the archetypes they aspire to, but not quite able yet to occupy that space.

In a statement that speaks directly to one of, if not *the* single most important question raised by this exhibition and essay, Judith Butler argues:

Becoming a man . . . requires a repudiation of femininity, but also a repudiation that becomes a precondition for the heterosexualization of sexual desire and hence, perhaps also, its fundamental ambivalence. If a man becomes heterosexual through the repudiation of the feminine, then where does the repudiation live except in an identification that his heterosexual career seeks to deny.[33]

In other words, men become men in the most conventional sense through the methodical suppression of every instinct that deviates from a narrowly defined set of normative, heterosexist behaviors. In this succinctly stated provocation, Butler isolates precisely the properties of difference — both gender and sexual — that must be excluded from the domain and discourse of sport in order that the normative character of this world be upheld. But she also suggests that such denial cannot be complete or totalizing, which in turn gives rise to the "ambivalence" that so many of the artists in this exhibition draw on to render their view of the male athlete.

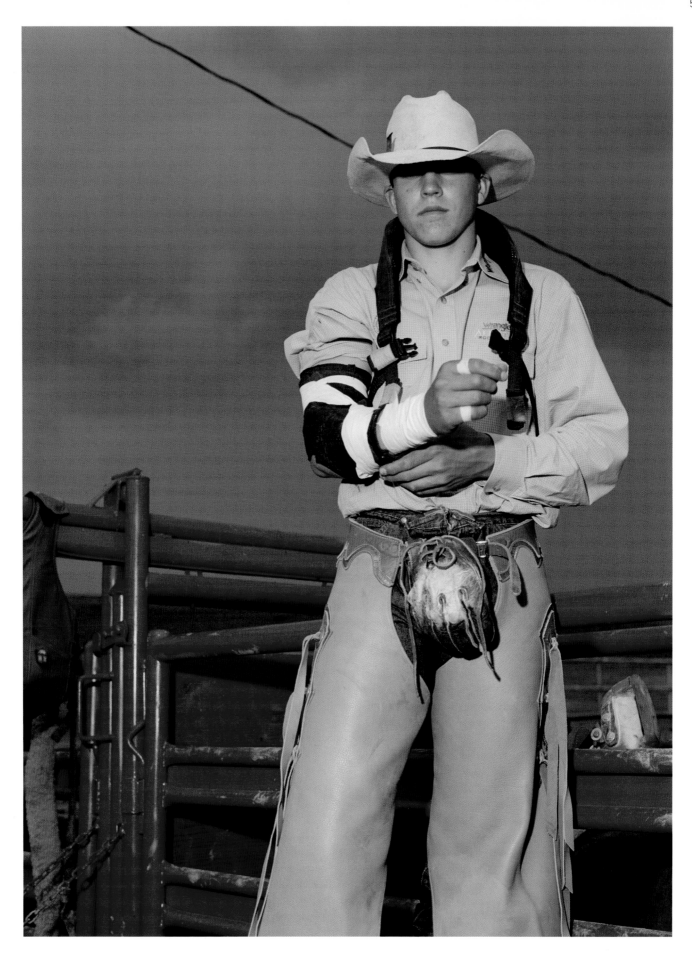

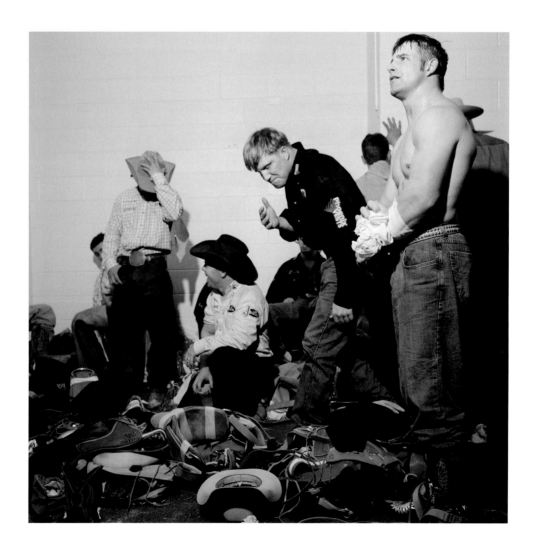

COLLIER SCHORR

opposite, above: *Cowboys (A Prayer Before Dying)*, 2008
Archival pigmented ink print on cotton-rag paper
21 × 27 in. (53.3 × 68.6 cm)
Courtesy the artist and 303 Gallery, New York

opposite, below: *Cowboys (The Best and the Brightest)*, 2008
Archival pigmented ink print on cotton-rag paper
21 × 27 in. (53.3 × 68.6 cm)
Courtesy the artist and 303 Gallery, New York

right: *Cowboys (Bareback)*, 2008
Archival pigmented ink print on cotton-rag paper
27 × 21 in. (68.6 × 53.3 cm)
Courtesy the artist and 303 Gallery, New York

below: *Cowboys (Bronc Rider)*, 2007
Archival pigmented ink print on cotton-rag paper
27 × 21 in. (68.6 × 53.3 cm)
Courtesy the artist and 303 Gallery, New York

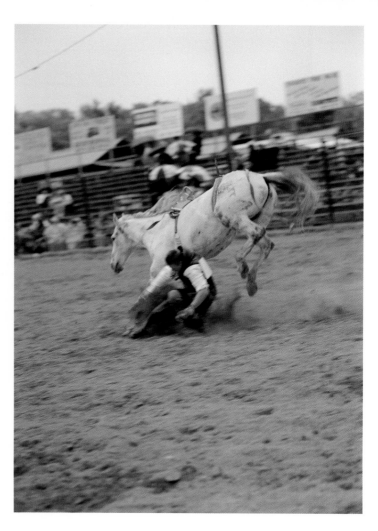

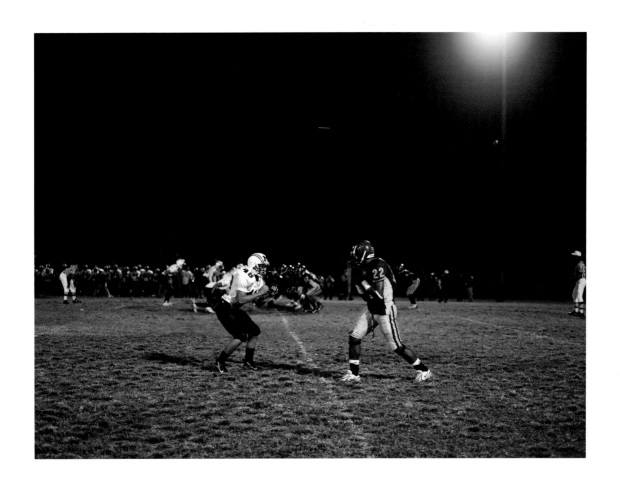

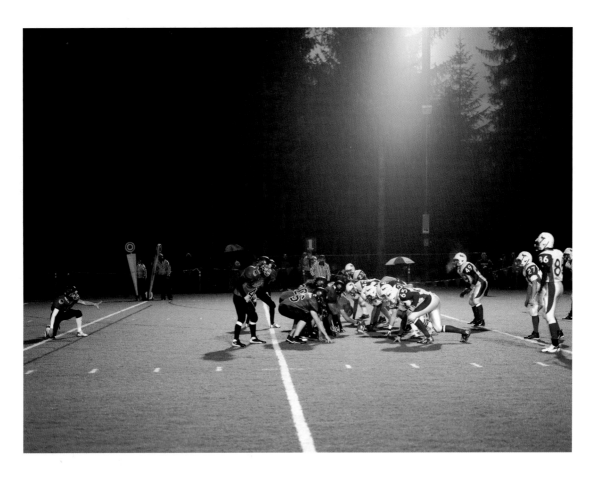

CATHERINE OPIE

Football Landscape #1 (Fairfax vs. Marshall, Los Angeles, CA), 2007
Chromogenic print
48 × 64 in. (121.9 × 162.6 cm)
Courtesy the artist and Regen Projects, Los Angeles

Football Landscape #5, (Juneau vs. Douglas, Juneau, Alaska), 2007
Chromogenic print
48 × 64 in. (121.9 × 162.6 cm)
Courtesy the artist and Regen Projects, Los Angeles

Almost every work in this exhibition adopts this point of view, in order to develop an alternative vision of masculinity and sport, but not all of them do. One work that addresses the denial and repudiation of difference openly, analytically, and, refreshingly, with a sense of humor, is Joe Sola's mock-pastoral drama *In the Woods*, 2008, a video work that allegorizes the elusiveness and ambivalence of becoming a real man. The camera follows a camouflaged hunter as he emerges from amidst thick undergrowth with his rifle cocked, and, shortly thereafter happens upon a pink, arm-size portal into the interior space of a tree trunk inhabited by a large, liberally greased African-American bodybuilder and a slight Asian man. As the hunter reaches into the trunk, his hand flips a light switch, whereupon the Asian man falls to the ground inert and is picked up by the bodybuilder, who places him on a wooden rack for the hunter to extract a rainbow-colored bullet from the Asian man's mouth; and after loading his rifle with this bullet, the hunter disappears back into the undergrowth.

Sola uses the well-known sports aphorism "flip the switch"—which is commonly used to describe the ability of male athletes to achieve an exaggerated state of intensity and aggression—in order to draw critical attention to the disavowal of ambivalence necessary to achieve this state of masculine purity. *In the Woods* does not designate a means by which to short-circuit this process—to revise completely the conventions of gender expression that still underlay most male sports; however, in its light, yet persuasive description of the powerful reverse mechanism, Sola playfully opens up the possibility that the ambivalence Butler identifies as fundamental to the formation of the thor-

oughly socialized heterosexual male need not be discussed exclusively in terms of airtight denial of instincts that deviate from the norm. Like Barney, who used (and continues to use) hermetic allegorical systems to focus attention on questions and problems that bear directly on the ways men shape and project their identities socially, Sola uses his mercurial, pastoral vignette to make a simple claim that is too sensitive to be articulated without the cushioning of humor and allegory: namely, that this process of methodical repudiation of difference/deviation within and among men may be far more conscious and broadly (if silently) understood within even the most regimented homosocial groups than is commonly acknowledged. The hunter's easy insertion of a rainbow bullet into his gun and the disappearance of his camouflaged form back into the undergrowth imply that the seed for a more varied, multilayered definition of the normative sportsman is not to be found exclusively in extrinsic models provided by feminism and queer theory—indeed, it may reside fully formed, yet hidden, in precisely those men who seem least accepting of, and therefore least pregnable to, this difference. The apparently vanguard questions of social identity raised by the works featured in *Mixed Signals* are outside—and, indeed, have always been outside—the prescribed limits of gender studies, art, and art history. These concepts simply require a discursive framework of descriptive, accessible language and suggestive forms that will help such ideas find their place within a broader public discussion. It is the fundamental aim of this exhibition to provide some of those structures.

For MSG

JOE SOLA

In the Woods, 2008 (detail; video still)
Single-channel video with sound
6 mins., 30 secs.
Courtesy Bespoke Gallery, New York

Notes

1. Don DeLillo, *End Zone* (New York: Penguin Books, 1986), p. 4.
2. Catherine Opie, in conversation with the author, April 29, 2008.
3. http://en.wikipedia.org/wiki/Catherine_Opie.
4. Herbert Sussman, "His Infinite Variety," *Artforum* (April 1994): 77.
5. Maurice Berger, ed., "Man Trouble," *Artforum* 32, no. 8 (April 1994). In that issue of *Artforum*, Berger included his own text, "A Clown's Coat," in which, while proposing the notions of "multiple identities" of "representing ourselves between identities," Berger discloses his homosexuality unambiguously: "I was still in the closet." It should also be noted that two other very significant books with a considerable stake in the constitution of male identity in representation emerged at or around this time: *The Masculine Masquerade*, ed. Andrew Perchuk and Helaine Posner (Cambridge, Mass.: M.I.T. Press, 1995) and *Constructing Masculinity*, ed. Maurice Berger, Brian Wallis, and Simon Watson (New York: Routledge, 2005).
6. Simon Watney, "Aphrodite of the Future," *Artforum* 32, no. 8 (April 1994): 76.
7. Tellingly, other wallpaper choices on adjacent pages include movie stills from Stanley Kubrick's *Full Metal Jacket* and Quentin Tarantino's *Reservoir Dogs*, offering a synopsis of two other relatively impregnable or at least resistant fields of imagery: violent crime and, of course, the military.
8. Sussman, "His Infinite Variety" (see note 4 above): 119.
9. For more on the reasons for this interpretative limitation, see Christopher Bedford, "Matthew Barney," *Burlington Magazine* 148 (November 2006): 797–99, and Christopher Bedford, "*REN*," *Frieze*, no. 117 (September 2008) http://www.frieze.com/issue/article/ren.
10. Norman Bryson, "Matthew Barney's Gonadotrophic Cavalcade," *Parkett*, no. 45 (1995): 30.
11. Ibid.: 30–31.
12. For more on this subject, see the essays by Judith Butler and Julia Bryan-Wilson in this exhibition catalogue.
13. Thyrza Nichols Goodeve, "Travels in Hypertrophia," *Artforum* 33, no. 9 (May 1995): 67.
14. Bryson, "Matthew Barney's Cavalcade" (see note 10 above): 33.
15. One notable exception is Jennifer Doyle's recent essay "Fever Pitch: The Art of Football" in *Frieze*, no. 116 (June–August 2008) http://www.frieze.com/issue/article/fever_pitch/.
16. Eve Kosofsky Sedgwick, *Between Men: English Literature and Male Homosocial Desire* (New York: Columbia University Press, 1985), p. 2.
17. Pat Conroy, *The Lords of Discipline* (First published 1980. New York: Dial Press, 2006), p. 45.
18. Shaun El C. Leonardo, e-mail to the author, December 20, 2007.
19. Jan Tumlir, "Joe Sola: Fish Out of Water," in *Joe Sola: Taking a Bullet* (Los Angeles: Los Angeles Contemporary Exhibitions, 2005), pp. 24–28.
20. Cécile Whiting, *Pop L.A.: Art and the City in the 1960s* (Berkeley and Los Angeles: University of California Press, 2006), p. 110.
21. Hank Willis Thomas, statement accompanying *B®anded* series, at http://hankwillisthomas.com/portfolio.html.
22. Matthew Higgs, "Brian Jungen in conversation with Matthew Higgs," in *Brian Jungen* (Vienna: Secession, 2003), p. 25.
23. Joyce Carol Oates, *On Boxing* (First published 1987. New Jersey: Ecco Press, 1994), p. 32.
24. Ibid., p. 30.
25. *Moving Equilibrium* was a one-night-only performance on May 11, 2006 at Crawford Hall Gym in Irvine, California.
26. The notion of normative gender as an accomplishment is taken from Judith Butler, "Melancholy Gender/Refused Identification," in *Constructing Masculinity* (see note 5 above), pp. 21–36.
27. Paul Pfeiffer quoted at http://www.pbs.org/art21/artists/pfeiffer/clip1.html.
28. H. G. Bissinger, *Friday Night Lights: A Town, a Team, and a Dream* (New York: Da Capo Press, 2000), p. xiv.
29. See *New York Times Magazine*, June 24, 2007: 56-63.
30. Pfeiffer quoted at http://www.pbs.org/art21/artists/pfeiffer/clip1.html
31. Collier Schorr, e-mail to the author, September 4, 2008.
32. Catherine Opie, in conversation with the author, April 29, 2008.
33. Butler, "Melancholy Gender" in *Constructing Masculinity* (see notes 5 and 26, above), p. 26

UNRULINESS,
OR WHEN PRACTICE ISN'T PERFECT

Julia Bryan-Wilson

In 2000, the U.S. Tennis Association unveiled a sculpture to honor the legacy of African-American tennis great Arthur Ashe (fig. 8). The fourteen-foot-high bronze figure stands in a landscaped area near the main entrance of the National Tennis Center in Flushing, New York, depicting a muscular nude male, one hand reaching toward the sky as if in midserve, the other grasping a broken tennis racket. Designed by artist Eric Fischl, the statue, entitled *Soul in Flight*, is not meant to be a literal representation or portrait of the sports figure, but a gestural evocation of the dynamism of Ashe's actions on and off the court.

Almost immediately, the sculpture came under criticism, not only for failing to recognizably resemble the tennis star — its beefy form is far from Ashe's legendarily slender frame — but also for the audacity of the nakedness and the perceived bleakness of the incomplete racket.[1] Fischl defended his choices, noting that the nudity recalled classical sculptures of athletes in motion, and that the racket stub alluded to a "life cut short" (Ashe died of AIDS in 1993).[2] This veiled reference to Ashe's death is notable given how the sculpture's hulking, healthy body contrasts to the realities of the ravages of the late stages of the disease, which can cause the flesh to waste away. Ashe was heterosexual, and contracted the disease from a blood transfusion, but long-standing presumption in the United States that AIDS is a "gay" affliction might have also motivated another of Fischl's decisions: Was the potent nakedness of the figure meant to offer a more conventional model of masculinity? Or did the sculpture's very exaggeration of virility make it somewhat queer?

The controversy over *Soul in Flight* thus revealed how Ashe embodied an unresolved contradiction: how can a male body celebrated for its physical agility be reconciled with its ultimate vulnerability? Indeed, sports is an arena in which ideas of masculine purity and bodily integrity are tested and refined. But it equally raises questions about male bodies that do not obey rules of strength and machinelike efficiency. This essay considers such accounts of non-normative identities (often dismissed as "imperfections") — queer, transgender, and differently abled — within artistic and cultural representations of sports. In other words, it looks at "unruly bodies" — bodies that resist confinement by traditional notions of gender and ability.[3] How is such unruliness represented — given form — within the realms of athletics and aesthetics, and what can it tell us about changing notions of masculinity?

Sports can be an especially precise lens for focusing on questions of sex and gender.[4] From ancient Greek statuary to George Bellows's heaving boxers, the athletic male body has frequently been idealized in art as the embodiment of sleekness and power. At times this glorification of physical flawlessness can dovetail with more sinister visions, such as racist beliefs in Aryan supremacy and eugenics programs to weed out genetic undesirables. For instance, one of Hitler's favorite artists, sculptor Arno Breker, was celebrated in Nazi Germany for works such as *Bereitschaft (Readiness)*, 1939 (fig. 9), which showed the male physique at its most fascistically forceful. In Breker's work, bodies stand tall and rigid, unmarred by weakness, injury, or illness — such ruptures are unthinkable within

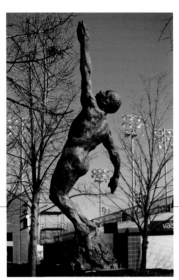

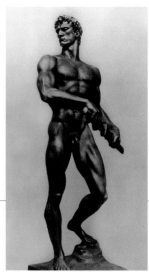

Fig. 8: Eric Fischl. *Soul in Flight*, 2000. Bronze. 176 × 68 × 50 in. (447 × 172.7 × 127 cm). Courtesy Eric Fischl Studio

Fig. 9: Arno Breker. *Bereitschaft (Readiness)*, 1939. Courtesy Europäische Kultur Stiftung

the logic of his pristine, brutish racial perfection. What is more, their emphatic masculinity appears unquestioned.

Fischl's symbolic likeness of Ashe is quite unlike Breker's figure, given its acknowledgment — however subtle — of mortality, much less its glorification of a black athlete. Yet in Breker and Fischl alike, the anxious, even over-compensatory assertions of maleness demonstrate that artistic representations of sports reveal masculinity as an unfixed concept that must be repeatedly enacted and enforced. As theorist Judith Butler has influentially written, "Gender is in no way a stable identity or locus of agency from which various acts proceed; rather it is an identity tenuously constituted in time — an identity instated through *a stylized repetition of acts*."[5]

The notion of gender not only as a performance, but also a kind of disciplinary training (to key more precisely into the realm of athletics) has been explicitly theorized by Michel Foucault. In his *History of Sexuality*, he discusses how "bio-power" subjects gender to a closed system that is unwilling to account for variation.[6] Discourses of medicalization and education have enforced the notion that the so-called "truth" of sex and gender is physically fixed, and demand that the body constantly undergo a series of regimes of maintenance and upkeep to keep it in place. Some of the extreme subcultures of contemporary sport have taken such Foucauldian notions as practice, training, and discipline to new levels, focusing on strictly calibrated nutrition, performance-enhancing drugs, and body modifications intended to help athletes reach new heights of accomplishment.

Foucault's and Butler's writings are part of a rich literature about the fluidity of gender; though widely accepted within the academic realm of queer theory, their ideas are not widely embraced in the mainstream sporting world. More than almost any other realm of contemporary culture, organized sports illuminates how the presumed fixity of gender is codified and upheld. During the 1960s, officials from the International Olympic Committee began to demand "sex verification" of female athletes — administering chromosomal tests as well as physical examinations to verify their "true" gender. There has only been one documented case of a male pretending to be a female to gain competitive advantage in sports: German high jumper Hermann Ratjen, who in 1936 was forced by the Nazi regime to participate in the Olympics as "Dora." (He came in fourth, and reverted back to his male identity when the games were over.) Still, over the past few decades, such tests have banned runners (such as Polish runner Ewa Klobukowska, who was deemed "abnormal" in 1967) and stripped others of their medals (Indian runner Santhi Soundarajan was forced to relinquish her silver medal from the 2006 Asian Games). As recently as the 2008 Beijing Olympics, despite an outcry from the medical establishment, a "sex determination laboratory" examined "suspect" females.[7]

Such tests assume that gender is defined by a rigid idea of biological "normality" in which there are only two choices: male or female. In fact, there is a wide spectrum of chromosomal variation, as well as a host of diverse physical characteristics along the gender continuum. Transgender author Jennifer Finney Boylan objected to these repressive tests, saying, "The Olympic hosts seem to want to impose a binary order upon the messy continuum of gender. They

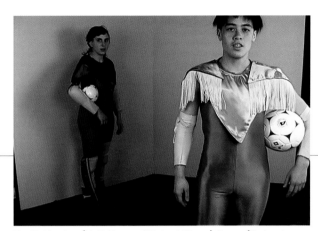

Fig. 10: Marriage (Math Bass and Wu Ingrid Tsang). *Soccer (Fortunate Living Trilogy)*, 2004 (video still). Single-channel color video. Courtesy Wu Ingrid Tsang

are searching for concreteness and certainty in a world that contains neither."[8] Public awareness of the fluidity of gender — due to genetic variations as well as many individuals' self-chosen identifications — has grown as transgender and intersex activists have demanded rights and pushed for visibility.

In 2004, despite this increased awareness of the malleability of gender identity, the International Olympic Committee deemed that transgender athletes could compete in the games, but only if they had had sex-reassignment surgery and lived for at least two years undergoing hormonal treatments. Thus, only those who had fully, bodily transitioned from one sex to another within these medicalized conditions met the requirements for eligibility, while those who might inhabit a more unfixed gender identity did not. Such policing of what constitutes proper masculinity and femininity is anathema to progressive queer activism. In this, the Olympics are several steps behind the times. Yet while athletics can be used to reinforce gender normativity, it can also provide a place where such normativity is constantly being discomfited and departed from. Queer and trans-people of course participate widely in sports (so much so, that they have in some instances become a kind of stereotype, as in the paradigmatic dyke softball team). These arenas of play celebrate a diversity of bodies and abilities that departs from the disciplinary regimes of some sectors of organized sports; in addition, alternative fan cultures that come together around watching sports can beget queer affective relations that exceed the presumed heterosexism within sports fandom.

Queer art that addresses sports has become a fertile site in which to imagine bodies without borders. Take, for instance, art duo Marriage (Math Bass and Wu Ingrid Tsang), whose short video *Soccer*, 2004, from their *Fortunate Living Trilogy* (fig. 10), shows two players of somewhat indeterminate gender practicing their soccer moves to an intermittent soundtrack of music by Queen. Here, Bass and Tsang — who perform the roles of the athletes in the video — deploy sports gear as a sort of prosthetic device that questions its relationship to masculinity. Their bodies are encased in kneepads and theatrical, brightly colored spandex suits (fringed at the shoulders), as they use the soccer ball to engage in a series of exercises. These aerobics do not ever culminate in a game, but seem to be rehearsed entirely for their own exhausting pleasure. As one artist cradles the ball into his/her crotch (incongruously, with hands sporting red fingernails), a visible pun about masculine "balls" becomes evident. Such movements — rolling the ball with their heads, kicking, and stretching — mimic and make absurd the repetitive nature of "training" in terms of both sexuality and sports. If sports is a proving ground for perfecting masculinity, Marriage's wonderfully unruly bodies create their own radical, queer vision of fitness, practice, and performance.

Definitions of what constitutes physical perfection, like the debates about athletes deemed to be "abnormal" in terms of gender, are constantly changing; such shifts also shed light on contemporary ideas of able-bodiedness. And there is significant overlap between the fertile fields of queer theory and disability studies. Queer disability studies posits that the ideas of physical normativity are

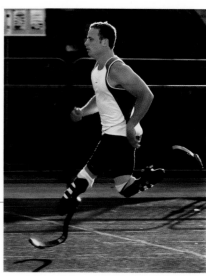

Fig. 11: South African amputee and champion runner Oscar Pistorius, sprinting at a training session in Pretoria, South Africa, June 21, 2007

discursively constructed within frames of power that do not acknowledge levels of otherness or difference. Self-declared "crip theorist" Robert McRuer speculates that "the system of compulsory able-bodiedness that produces disability is thoroughly interwoven with the system of compulsory heterosexuality that produces queerness."[9] Traditional standards of bodily integrity — such as the elevation, even worship, of athletes in pop culture — suggest that "deviant" or unruly trans, intersex, and disabled bodies alike that do not fit these norms are "broken" and need to be "fixed."[10]

However, recent developments indicate a move away from an intractable system that polices which bodies count as "whole" and which do not. After a lengthy legal battle, in May 2008, Oscar Pistorius (fig. 11), the South African double amputee and Paralympic running champion, successfully petitioned the International Association of Athletic Federations to reverse its ruling about the use of prosthetics in competitions. (He aimed to compete in the Beijing Olympics as the first-ever runner without legs, but his dream was postponed when he failed to qualify for the South African team.) Pistorius wears a pair of "cheetah feet" — high-tech C-shaped carbon-graphite devices that, unlike previous artificial legs, do not mimic human anatomy, and whose springlike flexion provides the runner with great shock absorption. Some feared that these prosthetics were so efficient that they would give him a competitive advantage. In fact, so drastic are the desires for victory at any cost that some commentators even postulated that athletes with healthy legs would consider cutting off their limbs to use such devices.

Does this turn of events — able-bodied athletes threatened by an amputee — signal that the tide is turning in terms of our comfort level with man-made physical interventions? Many athletes today, who are using individually configured outfits and equipment, wind-tunnel training tubes, and constant monitoring and feedback technologies, are already at the cutting edge of certain types of body modification. Yet the controversy over Pistorius reveals that this matter is by no means clean-cut, and with every new technology comes new rules and hand-wringing about the degradation of the ostensible purity of sports.

In contrast, at the forefront of thinkers who have advocated blurring the divisions between humans and machines is feminist theorist Donna Haraway. She has called for an embrace of cyborgism — an acceptance of incomplete, partial, and unruly identities that are able to promote strategic alliances between and across differences. Haraway turns to the question of prosthetics precisely as a model for how to envision such a politics of flexibility: "Perhaps paraplegics and other severely handicapped people can (and sometimes do) have the most intense experiences of complex hybridization with other communication devices."[11] Artists such as Matthew Barney have made use of prosthetic devices not to contest impossible ideals of human perfection, but as aesthetic extensions of the imagination — for example, double amputee Aimee Mullins wearing clear legs that end in tentacles in his film *Cremaster 3*, 2002, a troublingly exoticized depiction that many have taken issue with.[12] More often, Barney has mined the pageantry and fetishization of sports as a way to play out complex fantasies about

how the performance of masculinity is indebted to ritual and spectacle.

In contemporary U.S. culture, sports has been cast as a pioneering terrain where barriers are dismantled. Most famously, the baseball field was integrated before the schoolyard, and athletes such as Jackie Robinson were heralded as critical to changing race relations in this country. But this myth of sports as culturally progressive is paradoxical, as the terms by which its pluralism is enacted are often limited and compromised (as ongoing "gender testing" has made clear). Although it can be a transformative realm in which prejudices are overcome, sports can also be conservative, fighting to maintain myths of physical integrity. With its punitive policing of transgender and intersex identities, mainstream sports has become one of the last bastions of gender essentialism.

Art, though, continues to provide a space of possibility, a place to envision and depict a world beyond gender binaries as well as bodies unconfined by distinctions between the natural and artificial. The artists whose works are featured in *Mixed Signals* depict the masculine body not as a flawless machine but as unfixed and porous. At a time when sports (uncertainly) upholds codes of normative masculinity, queer theory and disability studies give new ways to think about the corporeal, ritualistic aspects of physical upkeep, practice, and training that do not reify one standard of physicality but are adaptable, supple, and functional. In other words, art is often able to celebrate variability and a blurring of masculine identities in a way that conventional sports has not — yet. To return to Fischl's statue of the male body arrested in motion, with broken racket in hand: is it not just as critical for art to make visible the poignant moments of physical failure, of mortality — the missed serve, the life cut short — as it is to embody perfection?

Notes

1. Ira Berkow, "Sports of the Times; Bronze Guy Stands Tall Sans Towel," *New York Times* (September 7, 2000): D1.

2. Quoted in F. T. Rea, "The Broken Racket," at *Richmond.com* (September 8, 2000): www.richmond.com/news-features/17940, accessed June 15, 2008.

3. I have taken the phrase "unruly bodies" from Suzannah B. Mintz, *Unruly Bodies: Life Writing by Women With Disabilities* (Chapel Hill: University of North Carolina, 2007). See also Tobin Siebers, "Disability Aesthetics," *Journal for Cultural and Religious Theory* 7 no. 2 (Spring/Summer 2006): 63–73. Other important essays on sexuality and sports include those in the volume *The Cultural Value of Sport: Title IX and Beyond*, special issue of *The Scholar and Feminist Online* 4, no. 4, ed. E. Grace Glenney and Janet Jakobsen (Summer 2006), and Jennifer Doyle's ongoing, intelligent writings about soccer, including her blog "From a Left Wing" (www.fromaleftwing.blogspot.com).

4. In fact, some of the earliest critiques of the construction of masculinity came from the field of sports theory, such as the work of sociologist Michael A. Messner. See "When Bodies are Weapons" (1985), reprinted in *Out of Play: Critical Essays on Gender and Sport* (Albany: SUNY Press, 2007). Recent work includes Toby Miller, *Sportsex* (Philadelphia: Temple University Press, 2000). For more on masculinity in art in particular, see Andrew Perchuk and Helaine Posner, *The Masculine Masquerade: Masculinity and Representation* (Cambridge, Mass.: M.I.T. Press, 1995).

5. Judith Butler, "Performative Acts and Gender Constitution: An Essay in Phenomenology and Feminist Theory," in *Writing on the Body: Female Embodiment and Feminist Theory*, ed. Katie Conboy, Nadia Medina, and Sarah Stanbury (New York: Columbia University Press, 1997), p. 402.

6. See especially Michel Foucault, *The History of Sexuality*, vol. 1: *An Introduction*, trans. Robert Hurley (New York: Vintage, 1980); and Foucault's introduction to *Herculine Barbin: Being the Recently Discovered Diary of a Nineteenth Century Hermaphrodite* (New York: Pantheon, 1980).

7. Katie Thomas, "A Lab Is Set to Test the Gender of Some Female Athletes," *New York Times* (July 30, 2008): C9.

8. Jennifer Finney Boylan, "The XY Games," *New York Times* (August 3, 2008): WK 10.

9. Robert McRuer, "Compulsory Able-Bodiedness and Queer/Disabled Experience," in *The Disability Studies Reader*, ed. Leonard J. Davis, 2nd edition (London: Routledge, 2006), p. 301. See also McRuer, *Crip Theory: Cultural Signs of Queerness and Disability* (New York: New York University Press, 2006).

10. See, for instance, Sumi Colligan, "Why the Intersexed Shouldn't Be Fixed: Insights from Queer Theory and Disability Studies," in *Gendering Disability*, ed. Bonnie G. Smith and Beth Hutchinson (Rutgers: New Brunswick, 2004), pp. 45–60.

11. Donna Haraway, *Simians, Cyborgs, and Women: The Reinvention of Nature* (New York: Routledge, 1991), p. 178.

12. For the fetishism of Barney's work with Mullins, see Marquard Smith, "The Vulnerable Articulate: James Gillingham, Aimee Mullins, and Matthew Barney," in *The Disability Studies Reader* (see note 9 above), pp. 309–19. For more on artistic representations of amputees, see Christopher Bedford, "'What is that ghastly lady doing there?' Marc Quinn's *Alison Lapper Pregnant* and the Ability of Art," presented at the College Art Association Annual Conference, New York City, February 15, 2007.

Excerpt from

PERFORMATIVE ACTS AND GENDER CONSTITUTION:

AN ESSAY IN PHENOMENOLOGY AND FEMINIST THEORY

Judith Butler

Gender is an act that has been rehearsed, much as a script survives the particular actors who make use of it, but which requires individual actors in order to be actualized and reproduced as reality once again. The complex components that go into an act must be distinguished in order to understand the kind of acting in concert and acting in accord which acting one's gender invariably is.

In what senses, then, is gender an act? As anthropologist Victor Turner suggests in his studies of ritual social drama, social action requires a performance that is repeated. This repetition is at once a re-enactment and re-experiencing of a set of meanings already socially established; it is the mundane and ritualized form of their legitimation.[1] When this conception of social performance is applied to gender, it is clear that although there are individual bodies that enact these significations by becoming stylized into gendered modes, this "action" is immediately public as well. There are temporal and collective dimensions to these actions, and their public nature is not inconsequential; indeed, the performance is effected with the strategic aim of maintaining gender within its binary frame. Understood in pedagogical terms, the performance renders social laws explicit.

As a public action and performative act, gender is not a radical choice or project that reflects a merely individual choice, but neither is it imposed or inscribed upon the individual, as some post-structuralist displacements of the subject would contend. The body is not passively scripted with cultural codes, as if it were a lifeless recipient of wholly pre-given cultural relations. But neither do embodied selves pre-exist the cultural conventions that

essentially signify bodies. Actors are always already on the stage, within the terms of the performance. Just as a script may be enacted in various ways, and just as the play requires both text and interpretation, so the gendered body acts its part in a culturally restricted corporeal space and enacts interpretations within the confines of already existing directives.

Although the links between a theatrical and a social role are complex and the distinctions not easily drawn — Bruce Wilshire points out the limits of the comparison in *Role-Playing and Identity: The Limits of Theatre as Metaphor*[2] — it seems clear that, even though theatrical performances can meet with political censorship and scathing criticism, gender performances in non-theatrical contexts are governed by more clearly punitive and regulatory social conventions. Indeed, the sight of a transvestite onstage can compel pleasure and applause, while the sight of the same transvestite on the seat next to us on the bus can compel fear, rage, even violence. The conventions that mediate proximity and identification in these two instances are clearly quite different. I want to make two different kinds of claims regarding this tentative distinction. In the theater, one can say, "This is just an act," and de-realize the act, make acting into something quite distinct from what is real. Because of this distinction, one can maintain one's sense of reality in the face of this temporary challenge to our existing ontological assumptions about gender arrangements; the various conventions which announce that "this is only a play" allow strict lines to be drawn between the performance and life. On the street or in the bus, the act becomes dangerous, if it does,

precisely because there are no theatrical conventions to delimit the purely imaginary character of the act — indeed, on the street or in the bus, there is no presumption that the act is distinct from a reality; the disquieting effect of the act is that there are no conventions that facilitate making this separation. Clearly, there is theater which attempts to contest or, indeed, break down those conventions that demarcate the imaginary from the real (Richard Schechner brings this out quite clearly in *Between Theatre and Anthropology*).[3] Yet in those cases one confronts the same phenomenon, namely, that the act is not contrasted with the real, but constitutes a reality that is in some sense new, a modality of gender that cannot readily be assimilated into the pre-existing categories that regulate gender reality. From the point of view of those established categories, one may want to claim, "But oh, this is really a girl or a woman," or "This is really a boy or a man," and further that the appearance contradicts the reality of the gender, that the discrete and familiar reality must be there, nascent, temporarily unrealized, perhaps realized at other times or other places. The transvestite, however, can do more than simply express the distinction between sex and gender, but challenges, at least implicitly, the distinction between appearance and reality that structures a good deal of popular thinking about gender identity. If the "reality" of gender is constituted by the performance itself, then there is no recourse to an essential and unrealized "sex" or "gender," which gender performances ostensibly express. Indeed, the transvestite's gender is as fully real as anyone whose performance complies with social expectations.

Gender reality is performative, which means, quite simply, that it is real only to the extent that it is performed. It seems fair to say that certain kinds of acts are usually interpreted as expressive of a gender core or identity, and that these acts either conform to an expected gender identity or contest that expectation in some way. That expectation, in turn, is based upon the perception of sex, where sex is understood to be the discrete and factic datum of primary sexual characteristics. This implicit and popular theory of acts and gestures as expressive of gender suggests that gender itself is something prior to the various acts, postures, and gestures by which it is dramatized and known; indeed, gender appears to the popular imagination as a substantial core that might well be understood as the spiritual or psychological correlate of biological sex.[4] If gender attributes, however, are not expressive but performative, then these attributes effectively constitute the identity they are said to express or reveal. The distinction between expression and performativeness is quite crucial, for if gender attributes and acts — the various ways in which a body shows or produces its cultural signification — are performative, then there is no preexisting identity by which an act or attribute might be measured; there would be no true or false, real or distorted acts of gender, and the postulation of a true gender identity would be revealed as a regulatory fiction. That gender reality is created through sustained social performances means that the very notions of an essential sex, a true or abiding masculinity or femininity, are also constituted as part of the strategy by which the performative aspect of gender is concealed.

As a consequence, gender cannot be understood as a role that either expresses or disguises an interior "self," whether that "self" is conceived as sexed or not. As performance that is performative, gender is an "act," broadly construed, which constructs the social fiction of its own psychological interiority. As opposed to a view such as Erving Goffman's, which posits a self that assumes and exchanges various "roles" within the complex social expectations of the "game" of modern life,[5] I am suggesting that this self is not only irretrievably "outside," constituted in social discourse, but that the ascription of interiority is itself a publically regulated and sanctioned form of essence fabrication. Genders, then, can be neither true nor false, neither real nor apparent. And yet, one is compelled to live in a world in which genders constitute univocal signifiers, in which gender is stabilized, polarized, rendered discrete and intractable. In effect, gender is made to comply with a model of truth and falsity that not only contradicts its own performative fluidity, but serves a social policy of gender regulation and control. Performing one's gender wrong initiates a set of punishments both obvious and indirect, and performing it well provides the reassurance that there is an essentialism of gender identity after all. That this reassurance is so easily displaced by anxiety, that culture so readily punishes or marginalizes those who fail to perform the illusion of gender essentialism, should be sign enough that on some level there is social knowledge that the truth or falsity of gender is only socially compelled and in no sense ontologically necessitated.[6]

Notes

This is an excerpt from an article that was first published in *Theatre Journal* 40, no. 4 (Dec., 1988), by John Hopkins University Press.

1. See Victor Turner, *Dramas, Fields, and Metaphors* (Ithaca: Cornell University Press, 1974). Clifford Geertz suggests in "Blurred Genres: The Refiguration of Thought," in *Local Knowledge, Further Essays in Interpretive Anthropology* (New York: Basic Books, 1983), that the theatrical metaphor is used by recent social theory in two often opposing ways. Ritual theorists such as Turner focus on a notion of social drama of various kinds as a means for settling internal conflicts within a culture and regenerating social cohesion. However, symbolic action approaches, influenced by figures as diverse as Emile Durkheim, Kenneth Burke, and Michel Foucault, focus on the way in which political authority and questions of legitimation are thematized and settled within the terms of performed meaning. Geertz himself suggests that the tension might be viewed dialectically; his study of political organization in Bali as a "theater-state" is a case in point. In terms of an explicitly feminist account of gender as performative, it seems clear to me that an account of gender as ritualized, public performance must be combined with an analysis of the political sanctions and taboos under which that performance may and may not occur within the public sphere free of punitive consequence.

2. Bruce Wilshire, *Role-Playing and Identity: The Limits of Theatre as Metaphor* (Boston: Routledge and Kegan Paul, 1981).

3. Richard Schechner, *Between Theatre and Anthropology* (Philadelphia: University of Pennsylvania Press, 1985). See especially, "News, Sex, and Performance," pp. 295–324.

4. In *Mother Camp* (Prentice-Hall, 1974), anthropologist Esther Newton gives an urban ethnography of drag queens in which she suggests that all gender might be understood on the model of drag. In *Gender: An Ethnomethodological Approach* (Chicago: University of Chicago Press, 1978), Suzanne J. Kessler and Wendy McKenna argue that gender is an "accomplishment" that requires the skills of constructing the body into a socially legitimate artifice.

5. See Erving Goffman, *The Presentation of Self in Everyday Life* (Garden City: Doubleday, 1959).

6. See Michel Foucault's edition of *Herculine Barbin: The Journals of a Nineteenth Century French Hermaphrodite*, trans. Richard McDougall (New York: Pantheon Books, 1984), for an interesting display of this.

EXHIBITION CHECKLIST

Note: height precedes width precedes depth; all dimensions provided are for unframed work unless otherwise specified.

MATTHEW BARNEY
Born 1967, San Francisco
Lives in New York

CREMASTER 4, 1994
35 mm film with sound
42 mins.
Courtesy Gladstone Gallery, New York

DRAWING RESTRAINT 10, 2005
Single-channel video with sound
59 mins., 20 secs.
Courtesy Gladstone Gallery, New York

MARK BRADFORD
Born 1961, Los Angeles
Lives in Los Angeles

Practice, 2003
Single-channel color video with sound
3 mins.
Courtesy the artist and Sikkema Jenkins
& Co., New York

Double Speak, 2008
Papier-mâché, wire, soccer balls, and
netting
Approx. 72 × 48 × 36 in. (182.9 × 121.9 ×
91.4 cm)
Courtesy the artist and Sikkema Jenkins
& Co., New York

Kobe I Got Your Back, 2008
Papier-mâché, wire, and basketball
Diam.: 20 in. (50.8 cm)
Courtesy the artist and Sikkema Jenkins
& Co., New York

MARCELINO GONÇALVES
Born 1969, San Diego, California
Lives in Los Angeles

Receiver, 2002
Oil on panel
12 × 12 in. (30.5 × 30.5 cm)
Collection of Marcia Goldenfeld Maiten
and Barry Maiten, Los Angeles

Untitled, 2006
Oil and graphite on panel
33 × 24 in. (83.8 × 60.9 cm)
Collection of the artist; courtesy
James Harris Gallery, Seattle

LYLE ASHTON HARRIS
Born 1965, New York
Lives in New York

Memoirs of Hadrian #1, 2008
Pigment print on satin paper
34 × 30 in. (86.4 × 76.2 cm)
Courtesy Adamson Gallery/Editions,
Washington D.C.

Memoirs of Hadrian #31, 2008
Pigment print on satin paper
34 × 30 in. (86.4 × 76.2 cm)
Courtesy Adamson Gallery/Editions,
Washington D.C.

Memoirs of Hadrian #38, 2008
Pigment print on satin paper
34 × 30 in. (86.4 × 76.2 cm)
Courtesy Adamson Gallery/Editions,
Washington D.C.

Memoirs of Hadrian #39, 2008
Pigment print on satin paper
34 × 30 in. (86.4 × 76.2 cm)
Courtesy Adamson Gallery/Editions,
Washington D.C.

BRIAN JUNGEN
Born 1970, Fort St. John, British Columbia
Lives in Vancouver

Prototype for New Understanding #12,
2002
Nike Air Jordans
23 × 11 × 12 in. (58.4 × 27.9 × 30.5 cm)
Collection of Ruth and William True,
Seattle

Michael, 2003
Screen print on powder-coated aluminum,
10 boxes
Installation dimensions: 34 × 44 × 33 in.
(86.4 × 111.8 × 83.8 cm)
Rennie Collection, Vancouver

Blanket no. 2, 2008
Professional polyester sports jerseys
53 × 51½ in. (134.6 × 130.8 cm)
Courtesy the artist and Casey Kaplan
Gallery, New York

Blanket no. 3, 2008
Professional polyester sports jerseys
54 × 47 in. (137.2 × 119.4 cm)
Courtesy the artist and Casey Kaplan
Gallery, New York

KURT KAUPER
Born 1966, Indianapolis, Indiana
Lives in New York

Study for "Bobby #3," 2006
Graphite on paper
40 × 26 in. (101.6 × 66 cm)
Courtesy Deitch Projects, New York

Study for "Shaving Before the Game," 2007
Graphite on paper
41 × 26 in. (104.1 × 66 cm)
Courtesy Deitch Projects, New York

SHAUN EL C. LEONARDO
Born 1979, New York
Lives in New York

Bull in the Ring, 2008
Polycarbonate football helmets, latex
prosthetics, Styrofoam heads, monofila-
ment, and PVC pipe ring
Approx. 96 × 96 × 96 in. (243.8 × 243.8 ×
243.8 cm)
Courtesy the artist and Rhys Mendez Gal-
lery, Los Angeles

Bull in the Ring, 2008
Four-channel video installation
8 mins.
Courtesy the artist

KORI NEWKIRK
Born 1970, New York
Lives in Los Angeles

Closely Guarded, 2000
Plastic pony beads, artificial hair, and
metal basketball hoops
120 × 48 × 24 in. (304.8 × 121.9 × 60.9 cm)
Collection of Lois Plehn

CATHERINE OPIE
Born 1961, Sandusky, Ohio
Lives in Los Angeles

Davionne, 2007
Chromogenic print
29 1/2 × 22 in. (74.9 × 55.9 cm)
Courtesy the artist and Regen Projects,
Los Angeles

*Football Landscape #1 (Fairfax vs.
Marshall, Los Angeles, CA)*, 2007
Chromogenic print
48 × 64 in. (121.9 × 162.6 cm)
Courtesy the artist and Regen Projects,
Los Angeles

*Football Landscape #5, (Juneau vs.
Douglas, Juneau, Alaska)*, 2007
Chromogenic print
48 × 64 in. (121.9 × 162.6 cm)
Courtesy the artist and Regen Projects,
Los Angeles

Josh, 2007
Chromogenic print
30 × 22 1/4 in. (76.2 × 56.5 cm)
Courtesy the artist and Regen Projects,
Los Angeles

Seth, 2007
Chromogenic print
30 × 22 1/4 in. (76.2 × 56.5 cm)
Courtesy the artist and Regen Projects,
Los Angeles

PAUL PFEIFFER
Born 1966, Honolulu, Hawaii
Lives in New York

John 3:16, 2000
DVD, L.C.D. screen, mounting arm and
bracket
2 mins.
Installation: approx. 7 × 7 × 36 in. (17.8 ×
17.8 × 91.4 cm)
Courtesy the artist and The Project,
New York

Four Horsemen of the Apocalypse (12),
2004
Fujiflex digital chromogenic print
48 × 60 in. (121.9 × 152.4 cm)
Courtesy the artist and The Project,
New York

Four Horsemen of the Apocalypse (28),
2007
Fujiflex digital chromogenic print
48 × 60 in. (121.9 × 152.4 cm)
Courtesy the artist and The Project,
New York

MARCO RIOS
Born 1975, Los Angeles
Lives in Los Angeles

Moving Equilibrium, 2006
Single-channel video with sound
5 mins., 3 secs.
Collection of Eileen Harris Norton,
Santa Monica

Moving Equilibrium (Level Sculpture), 2006
MDF particle board, aluminum, glass,
wood, Plexiglas, enamel, and water
96 × 7 1/4 × 13 1/4 in. (243.8 × 18.4 × 33.7 cm)
Collection of Eileen Harris Norton,
Santa Monica

COLLIER SCHORR
Born 1963, New York
Lives in New York

Cowboys (Bronc Rider), 2007
Archival pigmented ink print on cotton-
rag paper
27 × 21 in. (68.6 × 53.3 cm)
Courtesy the artist and 303 Gallery,
New York

Anonymous Cowboy, 2008
Archival pigmented ink print on cotton-
rag paper
27 × 21 in. (68.6 × 53.3 cm)
Courtesy the artist and 303 Gallery,
New York

Cowboys (A Prayer Before Dying), 2008
Archival pigmented ink print on cotton-
rag paper
21 × 27 in. (53.3 × 68.6 cm)
Courtesy the artist and 303 Gallery,
New York

Cowboys (Bareback), 2008
Archival pigmented ink print on cotton-
rag paper
27 × 21 in. (68.6 × 53.3 cm)
Courtesy the artist and 303 Gallery,
New York

Cowboys (Not Men), 2008
Archival pigmented ink print on cotton-
rag paper
27 × 21 in. (68.6 × 53.3 cm)
Courtesy the artist and 303 Gallery,
New York

Cowboys (The Best and the Brightest),
2008
Archival pigmented ink print on cotton-
rag paper
21 × 27 in. (53.3 × 68.6 cm)
Courtesy the artist and 303 Gallery,
New York

JOE SOLA
Born 1966, Chicago, Illinois
Lives in Los Angeles

Saint Henry Composition, 2001
Single-channel video with sound
5 mins., 7 secs.
Courtesy Bespoke Gallery, New York,
and the Wexner Center for the Arts,
Columbus, Ohio

In the Woods, 2008
Single-channel video with sound
6 mins., 30 secs.
Courtesy Bespoke Gallery, New York

SAM TAYLOR-WOOD
Born 1967, London
Lives in London

3-Minute Round, 2008
Two-channel video
3 mins.
Courtesy Jay Jopling/White Cube, London

HANK WILLIS THOMAS
Born 1976, Plainfield, New Jersey
Lives in New York

Basketball and Chain, 2003
Lightjet print
30 × 20 in. (76.2 × 50.8 cm)
Courtesy the artist and Jack Shainman
Gallery, New York

Scarred Chest, 2003
Lightjet print
30 × 20 in. (76.2 × 50.8 cm)
Courtesy the artist and Jack Shainman
Gallery, New York

Something to Stand on: The Third Leg,
2007
Polyurethane coating on MDF
49 × 41 × 3/4 in. (124.5 × 104.1 × 1.9 cm)
Courtesy the artist and Jack Shainman
Gallery, New York

PHOTO CREDITS

Cover: courtesy the artist and Jack Shainman Gallery, New York; p. 1: courtesy Casey Kaplan Gallery, New York; p. 2: courtesy Paul Pfeiffer and The Project, New York; p. 8: courtesy Bespoke Gallery, New York, and the Wexner Center for the Arts; pp. 10, 11, 12, 13: courtesy Regen Projects, Los Angeles; p. 14 (left): Perseus Books Group; p. 14 (right): © Artforum, April 1994 [page 76]; p. 15: courtesy Regen Projects, Los Angeles; p. 16: courtesy Gladstone Gallery, photo Reggie Shiobara, © 2005 Matthew Barney; p. 17: courtesy Gladstone Gallery, photo Michael James O'Brien, © 1994 Matthew Barney; p. 19: © Sam Taylor-Wood, courtesy Jay Jopling/ White Cube, London; p. 20: Photo: Marshall Astor; p. 21: courtesy Shaun El C. Leonardo and Sikkema Jenkins & Co., New York, Photo © 2008 LACMA/Museum Associates; pp. 22, 23: courtesy Bespoke Gallery, New York, and the Wexner Center for the Arts, Columbus, Ohio; pp. 24, 25: © Sam Taylor-Wood, courtesy Jay Jopling/White Cube, London; pp. 28, 29: courtesy the artist and Jack Shainman Gallery, New York; p. 31 (above): courtesy Catriona Jeffries Gallery, Vancouver and Trevor Mills Vancouver Art Gallery; p. 31 (below): courtesy Catriona Jeffries Gallery, Vancouver; pp. 32, 33: courtesy Casey Kaplan, New York; pp. 34, 35: courtesy Marcelino Gonçalves and James Harris Gallery, Seattle; pp. 36, 37: courtesy Deitch Projects, New York; pp. 40, 41, 42, 43: courtesy Adamson Gallery/Editions; pp. 44, 45: courtesy Sikkema Jenkins & Co.; pp. 46, 47: courtesy Marco Rios and Simon Preston, New York; pp. 48, 49: courtesy Paul Pfeiffer and The Project, New York; pp. 51, 52, 53: courtesy Collier Schorr and 303 Gallery, New York; p. 54: courtesy Regen Projects, Los Angeles; p. 56: courtesy Bespoke Gallery, New York; p. 59 (left): courtesy Eric Fischl Studio; p. 59 (right): courtesy www.museum-arno-breker.org; p. 60: courtesy Wu Ingrid Tsang; p. 61: courtesy Associated Press/Denis Farrell; p. 72: courtesy Collier Schorr and 303 Gallery, New York; back cover: courtesy Gladstone Gallery, photo Michael James O'Brien ©1994 Matthew Barney

iCI BOARD OF TRUSTEES

COLLIER SCHORR

Cowboys (Not Men), 2008
Archival pigmented ink print on
cotton-rag paper
27 × 21 in. (68.6 × 53.3 cm)
Courtesy the artist and 303 Gallery,
New York

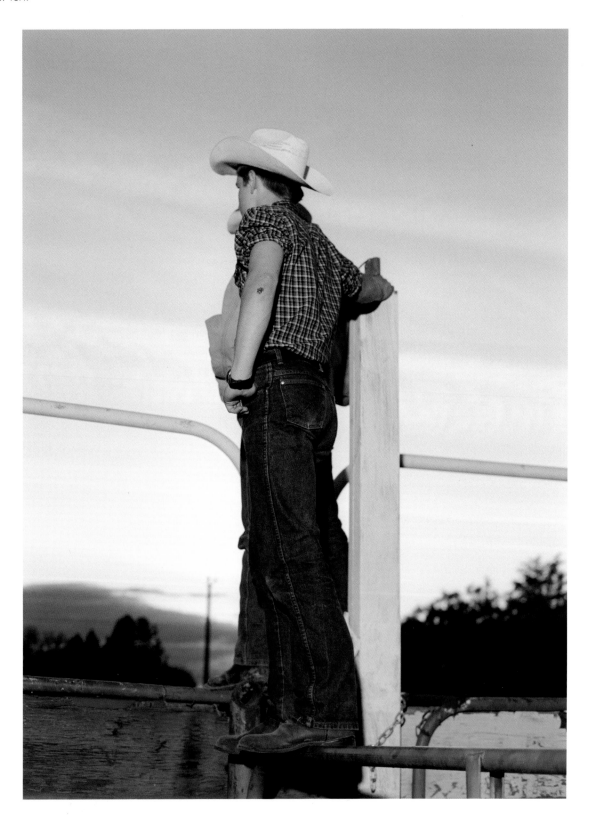